LEEDS

LEEDS

IVAN BROADHEAD

Smith Settle

First published in 1990 by

Smith Settle Limited
Ilkley Road
Otley
LS21 3JP

ISBN Paper 1 870071 62 X
Cloth 1 870071 63 8

Designed, printed and bound by
SMITH SETTLE
Ilkley Road, Otley, West Yorkshire LS21 3JP

DEDICATION

To my good friends
Stuart and Lilla Clarke

ACKNOWLEDGEMENTS

Enthusiastic help and encouragement towards preparing this book has come from many sources too numerous to detail here, since many of them were unwitting contributors in the course of discussion which indulged my curiosity.

I am particularly grateful to librarians and museum curators in Leeds and York, whose timely and strategic assistance in tracking down the elusive merits special attention. In particular I am indebted to Mrs Ann Heap, Leeds local history librarian; Peter Kelly, curator of Leeds Industrial Museum; Paul Larkin, curator of the Abbey House Museum; Paul Bookbinder of Marks and Spencer; Paul Austick of Austicks Bookshops; and Colin Waite of Joshua Tetley and Son Ltd.

I want to most sincerely thank Barrie Pepper, former press officer for Leeds City Council, for reading the manuscript and making valuable corrections; and finally my long-suffering wife Jean, for her patience, tolerance and continuous long-term encouragement in so many ways.

CONTENTS

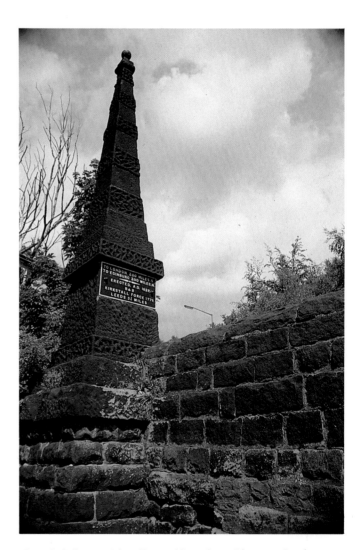

The obelisk at Kirkstall, marking the midway point between London and Edinburgh.

Where is Leeds? Southerners will tell you it is somewhere north of Watford Gap, whilst several Yorkshiremen aver that it crowns the M1 like a giant full stop on an inverted exclamation mark. Some may point to its strategic position astride the murky waters of the River Aire where Hol Beck, Sheepscar Beck and Wike Beck deposit their silts into the wider and faster-flowing torrent that wends its way into the Humber and ultimately the North Sea.

Standing virtually midway between London and Edinburgh, it is similarly placed in relation to Hull and Liverpool. In fact, Leeds is 56 miles from Hull, 73 miles from Liverpool, 191 from London and 193 from Edinburgh – even though an obelisk at Kirkstall conveniently places it exactly 200 miles equidistant from the metropolis and Scottish capital.

The East and West Coasts are conveniently linked through Leeds by the M62, and passing through its eastern extremity is the Great North Road or A1, providing a north-south axis. Small wonder, then, it claimed to be the 'Motorway City of the Seventies'. More recently, electrification of the railway to London has provided dramatic time-savings for rail travellers, and the expanding airport at Yeadon – which Leeds shares with Bradford – offers regular services to Europe as well as provincial cities.

Like the source of the river that runs through it, the origins of Leeds are submerged in obscurity, although theories to account for its presence are legion. One writer suggests that Leeds was the seat of the royal court of the Scandinavian Kings of Northumbria, whilst another says it was the residence of the Angle kings. Others claim a Roman station was sited here with a road and paved ford over the Aire – evidenced by the Calls, derived from the Latin *callis*, meaning a

One of the new electric trains which link Leeds with London.

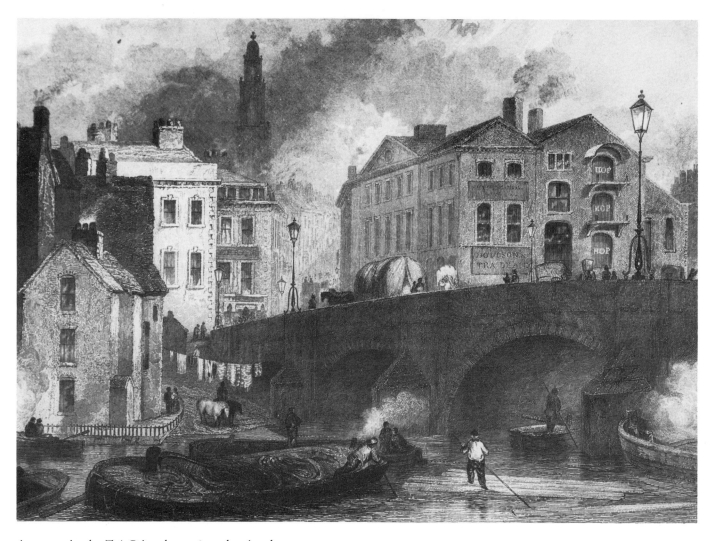

An engraving by T A Prior about 1849, showing the entrance to
Briggate over the old Leeds Bridge.

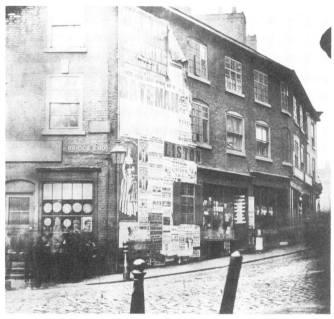

Peeling posters once added to the drabness of the Bridge End approach to the city from the south.

An indication of the popularity of alcohol refreshment in bygone days is this scene at Bridge End at the bottom of Briggate.

beaten path. But all seem mythical, resting only on imaginative yearnings rather than a foundation of factual evidence. In reality the relics and evidences of prehistoric times found in the city itself are only scanty.

The earliest mention of Leeds is made by the Venerable Bede writing in the early eighth century. He refers in his *History of the English Church and People* to *'regione quae vocatur Loidis'*; but whether this refers to Leeds as we know it, or to the district surrounding it, is equally obscure.

The first reliable written record occurs in the *Domesday Book* of 1086 where we are told:

'In Ledes [Leeds] there are ten carucates and six bovates of land for geld. Land to six ploughs. Seven thanes held it in the time of King Edward for seven manors. Now, twenty-seven villanes and four sokemen and four bordars have fourteen ploughs there. A priest is there and a church, and a mill of four shillings [annual value] and ten acres of meadow. It was worth six pounds, now seven pounds.'

Other townships mentioned in the survey are Ermelai (Armley), Bestone (Beeston), Brameleai (Bramley), Alreton (Chapel Allerton), Hedingleia (Headingley), Hunslet, Caldecotes (Coldcotes) and Ossethorpe (Osmondthorpe). Many of these are described as 'waste'.

In 1086, Leeds became part of the vast areas of land belonging to Ilbert de Lacy of Pontefract Castle; the implication is that the de Lacys quickly restocked

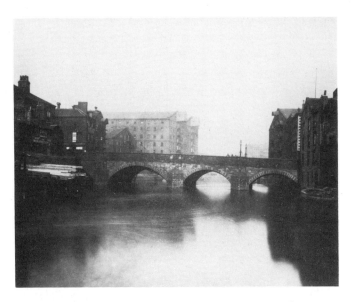

The old Leeds Bridge looking east about 1866, some four years before it was removed.

Leeds with men, animals, and ploughs at the expense of less promising manors in their barony, possibly in recognition of its importance as a river crossing settlement.

The birthplace of the city was undoubtedly the ford from Call Lane to Dock Street, and the earliest evidence of any structure here occurs when we are told a murder was committed on the 26th January 1389 'at the end of the bridge of Ledys'. Until 1648 the bridge served as a useful display unit for cloth merchants, with 'the cloths being laid upon the Battlements of the Bridge and upon benches below'.

According to one local chronicler:

'Cloth was made in Leeds before the reign of Edward the First, for in 1275 Alexander Fuller, a cloth maker of Leedes "makes cloth not of the right breadth".'

And in 1201, one Simon the dyer is fined 100 shillings for selling adulterated wine. Apart from short measure and adulteration being practised, we also find confirmation that two of its principal industries – cloth-making and dyeing – had their origin in early Norman times.

From the Norman era to the reign of King John, Leeds appears to have progressed considerably and advanced in importance, for on the 11th November 1207, Maurice Paynel, lord of the manor, granted a charter to the burgesses, conferring certain rights and privileges. From the granting of this charter to the time of Charles 1, comparatively little is recorded of the history and government of the town, and from the brief glimpses we do obtain there does not appear to have been any rapid development during that period.

The lord of the manor was a distant, absentee landlord – for example from 1361 to 1399 the lord was John of Gaunt, who as well as being Duke of Lancaster was also feudal King of Castile and Leon, Duke of Aquitane and Lord of Bergerac. The reasonance of these titles – if it carried at all to Leeds – could have had little practical significance to the men who were pushing back the forest, clearing the millstreams, planting grain and building in boulder stone the farms and houses of the manor.

Some idea of the extent of the town in Tudor times is contained in a crude freehand sketch – the earliest map extant – dated 1560. From this we can see that streets existing then form the heart of modern Leeds. Briggate was the axis and main business street. On the eastern side were Kirkgate and Lower Head Row, these two being linked up by Vicar Lane, which is indicated as having houses on the west side only. On the western side of Briggate the only outlet shown is Upper Head Row, with the exception of a lane leading from the lower part of Briggate to the King's Mill (the position of which is shown on the map). Near to it is also the 'Auncyant Manor House of Leeds, called Castyll

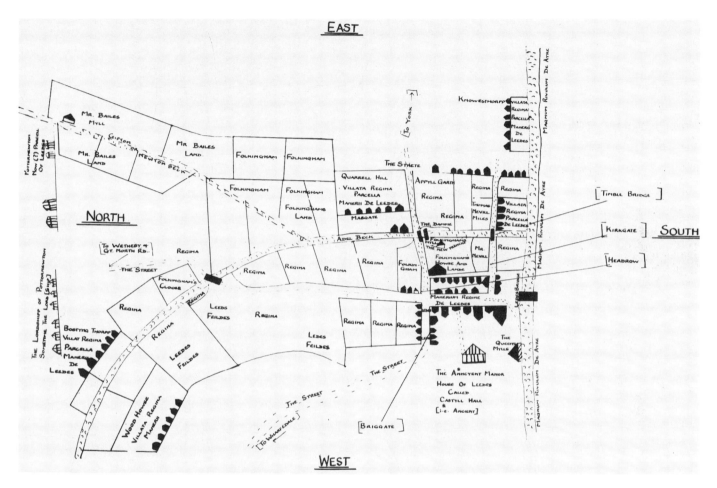

The earliest known map of Leeds, published about 1560.

Hill'. Lower Head Row and Upper Head Row at that time were two parts of a lane (or 'row') at the head of the eighty acres that was Leeds; the Headrow was not created until 1924.

A 'bill of complaint' was exhibited in Chancery on the 3rd November 1615, in which it is stated that the town and parish had become very large and populous, and consisted of more than 5,000 communicants; and that some of them were three or four miles distant from the church, yet 3–4,000 ordinarily went there every Sunday. This points to a considerable increase to the population, and also that a strong religious feeling existed at that time.

The parish church, dedicated to St Peter, may have

5

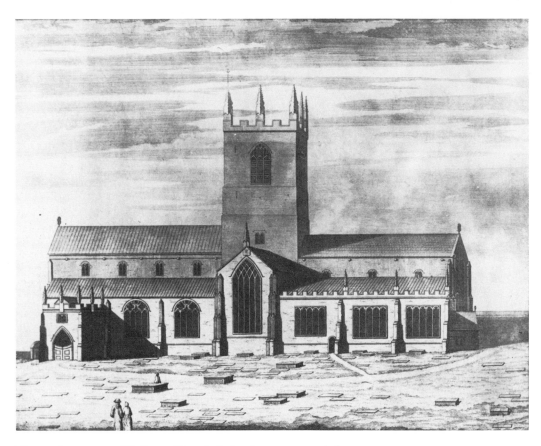

The south prospect of St Peters Church, before it was surrounded
by buildings and railway development.

foundations which go back down the shadowy aisles of time for some fifteen centuries, but as to the precise date the first church was erected on this site, history is again mute. If, as one writer claims, five structures have stood on this spot, it seems likely that a thatch and timber building was followed by one of more durable materials, lasting to around the eleventh century. The third church would undoubtedly have been of pure Norman architecture, with later additions up to the fifteenth century. This church seems to have been partly destroyed by fire, and a fourth church was demolished in 1838, to be followed by a new church on the lines of the old foundation being duly completed and consecrated on Thursday the 2nd September 1841. The vicar at the time was Dean Hook, whose endeavours were to make a big impact on the city both temporally and spiritually, leading to his commemoration with a statue in City Square .

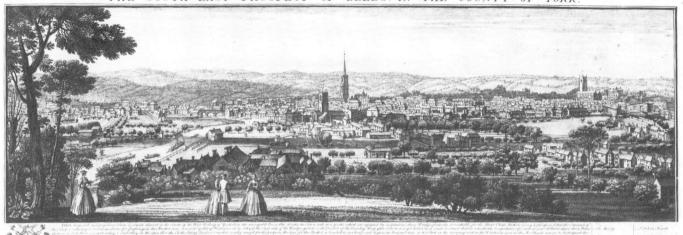

The south-east prospect of Leeds in 1745. In the centre are St Peters and Trinity Church, and on the right St Johns Church.

Local historian Ralph Thoresby described the previous church as 'Black, but comely'. This would have been a fitting description, reflecting a concern with the utilitarian rather than the reverential, compounded when an extension of the railway sliced right through the parish churchyard. In compensation, the railway company generously agreed to remove the gravestones and restore them as nearly as possible vertically above the right graves. Instead, with breathtaking audacity, they used the slabs to line the slopes of the embankment overlooking the church. They had some surplus. Over a century later, in mute memory of an environmental tragedy, the stones are still there awaiting re-erection. Adding insult to the injury was the fact that the new bells for the church are said to have been the first to travel to a site by railway, which they repaid by peeling in tribute at the opening of every new line to the city. In retrospect it is impossible to visualise the original church built, it is said, 'like a cathedral structure in a fruitful and enclosed vale'.

As a compliment to Sir John Savile (1556–1630), who was appointed first Alderman of Leeds by Charles I and whose personal coat of arms included three silver owls, the birds were included as supporters and crest in the city's first armorial symbol. On a shield was only one symbol – the fleece – symbolic of the staple trade.

When King Charles II granted a fresh charter in 1661, appointing Thomas Danby as the first mayor, a new coat of arms was devised by adding a black band at the top of the shield with three silver stars. This was done as a compliment to Danby, whose personal arms included these symbols. The Municipal Corporation Act of 1835 resulted in the reconstitution of the city corporation, and so the following year the motto *Pro Lege et Lege* – 'For King and Law' – was added.

7

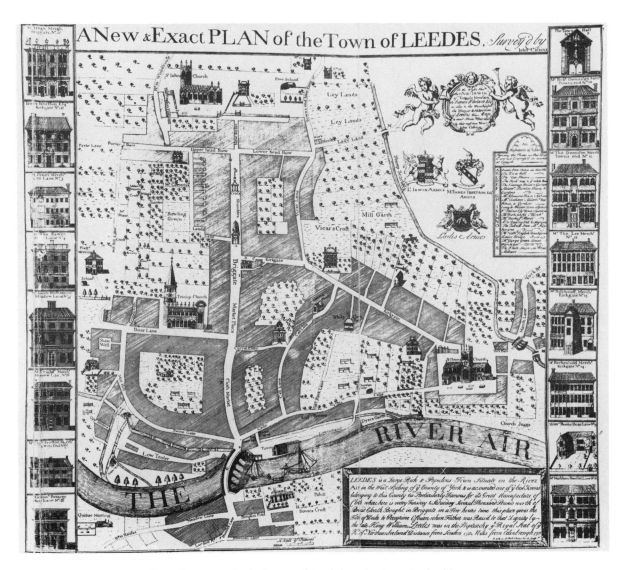

Recording not only the layout of Leeds but also its major buildings
is this plan from a survey by John Cossins in 1725.

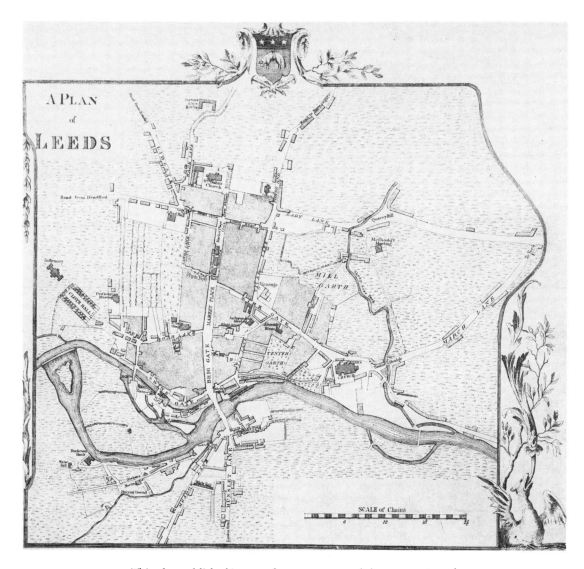

This plan published in 1775, from a survey made between 1767 and 1770, shows the limited area occupied by Leeds even in the eighteenth century.

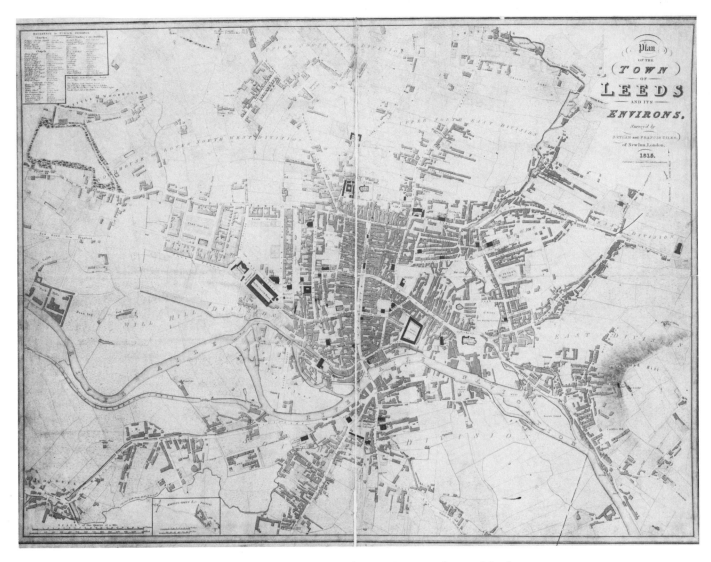

By 1815, Leeds had begun its burgeoning growth – as this plan
clearly shows.

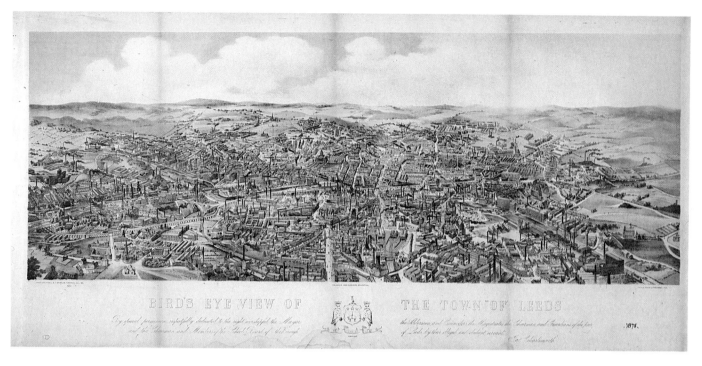

A bird's eye view of Leeds from 1875.

The silver owls turned brown in 1921 – not as a result of smoke-laden air but from the demands of heraldic accuracy. For nearly 300 years Leeds had flaunted an irregular coat of arms, the city having had no title to all of it. Although the shield and crest had been granted by the monarch, the other symbols in use for 295 years had not – a fact which someone chose to point out to the city council, who decided to regularise the position. As a result the silver owls became brown and a golden helmet was also added to the shield, these being recorded at the College of Arms in December 1921.

Civic pride begets civic emblems, and a strange tale attaches to the mayoral mace, which is inscribed *Arthur Mangey de Leeds facit 1694*. Civic pride apparently would not allow Mangey to ask more than £60 11s for the beautiful mayoral mace which he had fashioned for the town. He had charged only five shillings an ounce for the silver when the market rate was twice that sum.

Was this generous altruism to blame for his presence at York Assize Court on Saturday the 1st August 1696, charged with high treason in that he 'didst coyn twenty pieces of money mixt metal in imitation of the currant coyn of this Realme commonly called Shilling'? Witnesses declared Mangey to be not only honest but

perhaps the best goldsmith in Leeds, but in the light of overwhelming evidence Mangey was convicted and executed on the 2nd October 1696.

But Leeds wasn't born, it erupted. Because of local government reorganisation in 1974, this city on the Aire increased its population overnight by fifty per cent to 750,000, and its area to 211 square miles. Only Birmingham among provincial cities has more people within its boundaries. As a result Leeds is generously provided with parks and open spaces, nature trails having been opened up within minutes of the city centre.

But no city – with its inevitable concentration of dwellings, factories and manufacturing industry – is above criticism from an aesthetic and social standpoint; even new towns planned as a unit have a certain rawness. Leeds incorporated communities such as Headingley, Armley, Halton, Crossgates and Chapel Allerton, which have retained their village identity to a remarkable degree. Indeed the wheel has turned full circle. Seacroft still has its village green on which cricketers display their prowess, but it is now virtually a small town with its own light industry and town centre.

Extension of the Leeds boundaries has brought in market towns such as Otley and Wetherby, rural villages like Harewood, Bramham and Aberford, and townships as well-known as Pudsey, Morley and Garforth. Administratively they may now be part of Greater Leeds but socially and community-wise they retain their distinctive individualities. A man from Mars – or even Manchester – who visited Barwick-in-Elmet and saw the giant maypole, or the stone cottages of East Keswick, might well be surprised to learn that he was in Leeds. The more industrialised parts of Leeds to the south have also undergone a transformation, notably the demolition of the thousands of back-to-back houses for which Leeds was once notorious. Leeds is not yet a garden city, but there are many more gardens in the city, and rural vistas only five or six miles from City Square.

Because of its geography, its economic importance and its role as a university city, Leeds has become a regional capital. This fact has brought prestige and problems, but also the incentive to solve them. To the west lies the metropolitan city of Bradford, only ten miles distant yet a world apart. Like the ritualist posturing between two Japanese Sumo wrestlers squaring up for a bout, the two cities maintain an uneasy truce, the only apparently neutral ground being the shared airport at Yeadon. Otherwise they are said not to enjoy the same things, think in the same fashion, or share the same truths. Even the beer is different! Indeed at Stanningley in the early days of the tramways, the gauge of the track altered 'as surely as at any Russian border', according to a professor of economics.

Beyond the northern boundary lies Harrogate, that exclusive spa whose waters enabled it to gain international acclaim and a fragile gentility that evokes the dignity of culture and class to which Leeds aspires. The grand old man of history – York – some twenty-five miles to the north-east looks across with benign aplomb at the nascent metropolis, whose story spans but an instant in the timeless heritage of the walled citadel. To the south are the reviving industrial centres of Wakefield, Barnsley and Sheffield, each priming their challenge for the mantle which Leeds wears.

Demonstrating its visionary horizons, Leeds is twinned with Dortmund and Siegen, West Germany; with Ulan Bator in the Mongolian People's Republic; and with Lille, the textile town in north-east France. The Burgomeister of Dortmund, Herr Heinrich Sondemann, and Alderman A R Bretherick, the then Lord Mayor of Leeds, signed a deed of partnership in 1969, designed to establish 'a new era in cultural relations'. And to commemorate the tenth anniversary, Leeds named a pedestrian precinct

In the presence of officials, dignitaries and the official mace-bearer, the mayor opens the door of the municipal buildings and free public library.

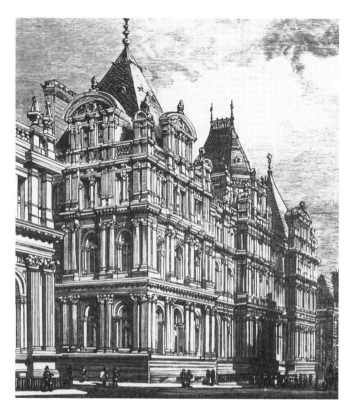

An exterior view of the municipal buildings.

Dortmund Square to accommodate a ten feet high bronze statue of a Dortmund drayman holding a barrel of beer. The statue, by sculptor Arthur Schulze-Engels, was a gift from the German town. Links with Ulan Bator go back as far as 1965, largely due to there being a Mongolian Studies Department at Leeds University, the only place in the Western world where Mongolian is taught.

Leeds, then, may be regarded as typical of the trading city of material growth and civic expansion.

Such places are not, as Matthew Arnold would have expressed it, steeped in sentiment, nor could that be expected; the spirit that animates them is practical, and the source of their inspiration must be sought rather in the Benthamite gospel of utility than in the incorruptible ideals of Pericles. Consequently Leeds is a very indefinite placename. Whilst it may have a precise meaning for its working-class population, for the more affluent it is what and where they want it to be. Rash is the man who, without careful qualification,

The mayoral mace is nearly 300 years old.

asks someone if they live 'in Leeds' and expects to get the right answer. Those who know their 'Leeds' experience no confusion. Only the 'incomers' betray their alienation by a thousand tell-tale signs of ignorance. Parochial chauvinism is alive and well in Morley, Otley, Wetherby, Adel, and elsewhere within the compass of the great industrial cuckoo. For the great curiosity of Leeds is that, even now, it is not a homogenous city, but a collection of villages and townships bounded together willy-nilly, with each component clinging obstinately to the shreds of individuality.

Who, then, is a Leeds man?

'I am Leeds', said city council leader Sir Charles Wilson at the boundary extension enquiry in 1921, in reply to a question about how Leeds could promote such efficiency and ruthlessness. Rather than an ego-trip, this statement seems to have been a laudable attempt at a clarion call designed to instil some sense of unity amongst those under the administrative yoke.

Dortmund Square alongside the Headrow.

Not for the true-born of Leeds, then, is there a romantic story about entering the world within the sound of Bow Bells or any similarly identifiable locus; but, in proclaiming his identity, he may claim to be a Leeds 'Loiner'. One explanation of this name suggests that since Loidis was the ancient name of the settlement, it is a corruption of that. Apparently undergraduates at Leeds University used to call townsfolk 'Loiners'. Since 'oiner' is an old university term for a cad, perhaps the Leeds lads added the 'L' for Leeds. One correspondent in the *Yorkshire Evening Post* dared to suggest it was a corruption of lion, and derived from the placement of the stone beasts outside the town hall. This brought the riposte from newspaper columnist John Wellington:

'Is there really any doubt that the time-honoured explanation accepted by generations of Leeds folk still stands? This is that the term came from the "loins" or "lanes" that ran from Briggate and other main Leeds streets. A loiner, or a laner, was a man who lived in one of these lanes.'

If pedantry is permitted, then perhaps a true Leodensian is one born within the boundaries of the medieval village, where cultivated land joined the grazing grounds. In medieval times the four boundaries were marked by stones. All trace of one of them has vanished, but the other three survive. East Bar stone is built into the boundary wall of the parish church near the war memorial to the men of the Leeds Rifles; North Bar stone can be seen at the bus station in Vicar Lane; and the third, known as the Burley Bar stone, first recorded in 1725, is preserved inside the main entrance of the Leeds and Holbeck Building Society at the junction of the Headrow and Albion Street (as an exterior plaque proclaims).

The bar stones were not toll bars, but marked the point outside which householders did not enjoy the same privileges as those within. For example, a twopenny tithe was paid by those living in the town,

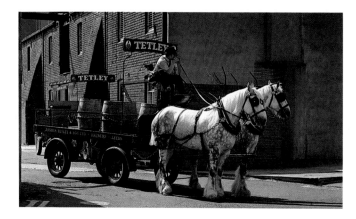

Tetley shire horses delivering beer in traditional fashion.

but threepence was levied on those outside. Prepaid letters were delivered free to those inside, whilst outsiders were charged one penny if they did not collect their mail from the post office.

The subject of this book, then, is Leeds at its heart and roots, where a colourful past collides with an invigorating present aimed at a dynamic future. It is a diverse and cosmopolitan city, but above all it is a city totally devoid of affectation.

I would like to put Leeds in a nutshell for you; but, like Carlyle's Mirabeau, it has 'swallowed all formulas'. Therefore I have been unashamedly selective, but I have tried to be accurate in detail, true to the spirit as well as the letter of its chronicles, for I should indeed be sorry to misinform or mislead you. If there are errors or omissions they are mine, and mine alone.

This book then – neither a comprehensive history nor tourist guide – seeks to show not only the physical face of Leeds but also the thread of continuity and the spirit of its people which makes it a place of infinite variety, truly deserving of Patrick Nuttgens' description as 'the back to front inside out upside down city'. That is *definitely* Leeds.

'Very Much Or Not At All'

'Thus, Thomas and Francis got to Leeds, of which enterprising and important commercial centre it may be observed with delicacy, that you must like it very much or not at all.'

So wrote Charles Dickens in *The Lazy Tour of Two Idle Apprentices*, when recounting the exploits of William Wilkie Collins and himself under the respective pseudonyms of Thomas Idle and Francis Goodchild. The year was 1857 and, even before he arrived in the city, Dickens, in a letter to a friend from Lancaster on Saturday the 12th September, was complaining:

'We are on our way to Doncaster; but Sabbath observance throws all the trains out; and although it is not a hundred miles from here, we shall have, as well as I can make out the complicated lists of trains, to sleep at Leeds – which I particularly detest as an odious place – tomorrow night.'

The two travellers lodged in comfortable quarters at the Scarbrough Arms in Bishopgate Street (then a family boarding house), and left next day to continue their railway journey to Doncaster – apparently without any challenge to his accusations. Dickens had come to Leeds a decade earlier, when he noted the railway station was 'a little rotten platform (converted into artificial torchwood by smoke and ashes)', which he had reached through 'branchless woods of vague black chimneys of the manufacturing bosom of Yorkshire'.

On that occasion he had found Leeds 'recovering from the double excitement of the Festival and the Queen,' resulting in the streets looking 'like a great circus with the season just finished. All sorts of garish triumphal arches were put up for the Queen, and they have got smoky, and have been looked out of

One of the best-known yards or lanes off Briggate houses Whitelock's luncheon bar, or the Turks Head as it is also known. This advertisement recalls days when prices were significantly different from today.

countenance by the sun, and are blistered and patchy, and half up and half down, and are hideous to behold'.

Nevertheless he could not afford to ignore the town, for as he recorded in a jotting of the 26th November 1847:

'The Leeds appears to be a very important [Mechanics] Institution and I am glad to see that George Stephenson will be there, besides the local lights, inclusive of the Baineses.'

On the 1st December, when he stepped on to the platform as chairman of a 1,000 strong meeting in support of the Leeds Mechanics Institution and Literary Society, he had a heavy cold. Yet he was still a dynamic performer, able to enthuse an audience who vigorously applauded his assertion that 'wherever hammers beat, chimneys smoke, there are masses of industrious human beings whom their Creator did not see fit to constitute all body, but into each and every one of whom He breathed a mind'. He pointed out that mechanics institutes were for the welfare of persons receiving a weekly wage, for it was ignorance that filled the prisons, bred blind violence, prejudice and terror.

A western panorama of Leeds in 1832, showing the view from Wellington Road with Wellington Bridge and Monk Bridge in the foreground.

And despite his jaundiced view he chose the mechanics institute in Leeds for his last appearance in Yorkshire, on the evening of Friday the 16th April 1869. The *Leeds Mercury* reported that an audience of 2,500 gave the great novelist a genuine Yorkshire welcome for a dramatic reading of Bill Sikes's murder of Nancy in *Oliver Twist*.

Perhaps the story struck a sympathetic chord with some of the populace, since an attempt to cut down mayhem and robberies by footpads in the streets had resulted in the promotion of an Act of Parliament as early as 1755 aimed at improving street lighting. As was pointed out to Parliament:

'The Town . . . is a place of great Trade and large extent, consisting of many streets, narrow lanes and alleys, inhabited by great numbers of Tradesmen, Manufacturers, Artificers and others, who in the prosecution and carrying on their respective Trades and Manufactures are obliged to pass and re-pass through the same, as well in the night as in the day time . . . several Burglaries, Robberies and other Outrages and Disorders have lately been committed and many more attempted . . .'

Oil lamps were used to light the town until the first gas lamps appeared in 1819 (one of the first areas to be illuminated was Hunslet, near Tetleys Brewery).

One of the earliest distinguished visitors to Leeds was the scholar John Leland (1506–52), who was moved to describe it as 'a praty market having one Paroche Church reasonably well buildid and as large as Bradeford but not so quik as it'.

By the beginning of the eighteenth century, visitors were surprised to find that the parish of 21,000 acres contained fourteen townships. Leeds itself was compact, centred on Briggate and the Headrow, and visibly impressed that intrepid lady traveller Celia Fiennes. She wrote in 1698 that 'Leeds is a large town . . . esteemed the wealthyest town of its bigness in the County'.

Leeds was emerging like a butterfly from a chrysalis, and by the time Daniel Defoe came in 1725 he was greeted with a 'large, wealthy and populous town'. He tells, too, of the famous 'Brigg-shot, where the clothier may, together with his pot of ale, having a noggin o' porrage and a trencher of either boiled or roast meat for twopence'.

In the same year, the bibliophile and connoisseur Edward Harley, second Earl of Oxford, discovered how bad the roads were around Leeds when he approached the city from Bramham after staying at Wetherby. He narrowly escaped being stuck in the road near the borough boundary at Moortown, and also had to negotiate his passage into Briggate through deep waters owing to flooding.

Like Defoe before him, he recorded an enthusiastic description of the cloth market, in which a tremendous amount of business was transacted in a miraculously short space of time – upwards of £30,000 in half an hour – by around 2,000 men, all in incredible secrecy and silence, with deals negotiated in whispers and murmurs. His lordship noted that buyers extended their caution by retaining 'only' one eighth of the

Looking across Leeds Bridge to the Golden Lion and Briggate.

Modern office development alongside the River Aire near Victoria Bridge.

purchase price as insurance against defect and fraud. Regretting that he had not had time to sample the famous meal of the clothiers, he pressed on to Wakefield, at what he regarded as no mean speed in the circumstances – two miles an hour.

The cloth market also proved a major attraction for the Portuguese visitor Don Manoel Gonzales in 1730. He was impressed by the continental ramifications of its trade, but also found time to admire the shops and profusion of food coming from distant parts, including in one day alone some 500 loads of apples.

Leeds was one of the many places included in the lifelong journey made by John Wesley. His *Journal* records his first visit to the city in 1743 – preaching on peace. He wrote:

'I preached at five, and at eight met the society after which the mob pelted us with dirt and stones the greater part of the way home. Next evening the mob was in higher spirits being ready to knock out all our brains'.

Another occasion saw him struck in the face several times. Nevertheless, within five years of his initial visit preaching at Quarry Hill to a hostile crowd, some 500 converts to Methodism had been recruited.

Taking the usual route of 'six computed miles' from Wakefield, Dr Pococke (afterwards Bishop of Meath) came in 1750, and naturally enough as a clergyman he was attracted to the 'very grand edifice' of Kirkstall Abbey and the splendours of Temple Newsam. He noted too that the town had a 'large fire engine for raising the water', and how the 'coal pits came close to their houses' in the district. Like many before him he was at pains to record conditions for travel at that time. Of the Skipton road he observed it was:

'. . . made of hewn free stone, about eighteen inches broad and a yard long, so the road is but three feet wide and not very secure for horses not used to it, though not apt to slip by reason of the softness of the stone. On these they ride when the roads are bad, as they are in most parts after rain.'

Prior to the passing of several local acts between 1740 and 1760 for the improvement of highways, the

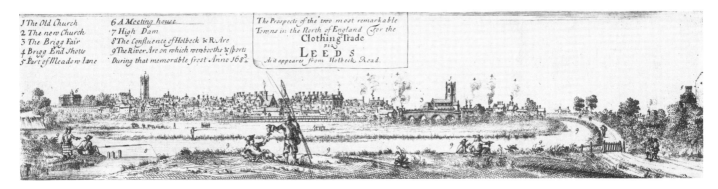

Leeds from Holbeck Road in 1712.

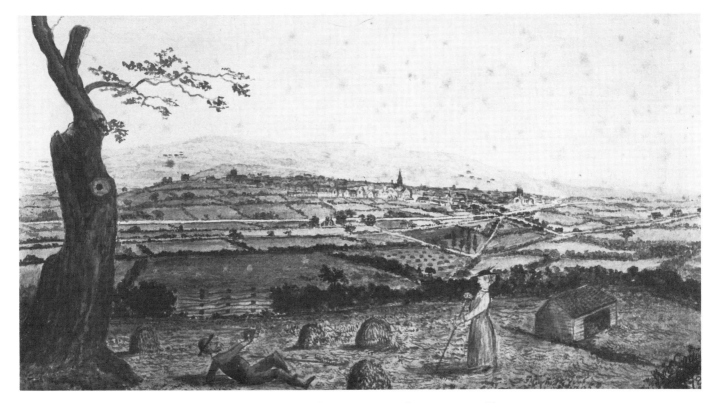

This rural view of Leeds in 1782 is from Beeston Hill.

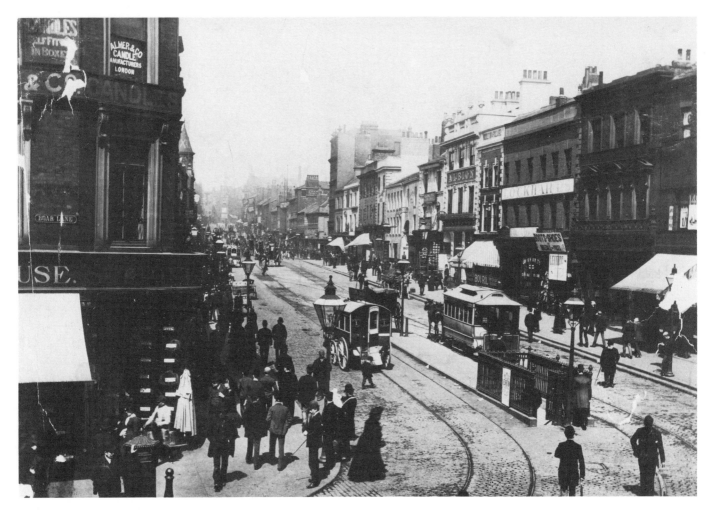

The junction of Boar Lane and Briggate about 1899.

The great cloth market, established by Edward III, as it appeared about 1640.

roads about Leeds were in a most deplorable condition, being nothing more in most cases than a narrow slip of rough flags leading across a common, with deep ruts on either side. Speaking of these roads, one historian says:

'They were sloughs almost impassable by single carts surmounted at the height of several feet by narrow worn tracks, where travellers who encountered each other sometimes tried to wear out each other's patience rather than either would risk a deviation. Carriage of raw wool and manufactured goods was performed on the backs of single horses at the disadvantage of nearly two hundred to one compared to carriage by water. At the same time and long after, the situation of the merchant was toilsome and perilous. In winter, during which season the employment of the working manufacturer was interrupted, the distant markets never ceased to be frequented. On horseback before daybreak and long after nightfall these hardy sons of trade pursued their object with the spirit and intrepidity of the foxchase, and the boldest of their country neighbours had no reason to despise their horsemanship or their courage. Sloughs, darkness, and broken causeways certainly presented a field of action no less perilous than hedges and five-barred gates.'

Pounding the road from Wakefield in 1777, which ran into the town 'through a country black with coal pits and the smoke of the fire engines and glass-houses', came William Bray in search of antiquities and picturesque sights. In the summer of the same year, a more charitable view was taken by keen-eyed American refugee Samuel Curwen. Travelling by post chaise from Sheffield, he saw another vista of good roads and fertile land as he concluded:

'The face of the country is more pleasing and the lands in better improvement and more people than in more than twenty counties.'

He stayed long enough to gain the impression that Leeds was 'said to contain 10,000 people, many well-filled shops, and various trades; its principal business in narrow and coarse woollen cloths, consigned to foreign orders, but little to London or inland trade; many of its merchants are wealthy'.

Horses and carts in Call Lane in 1885.

Tramcars clanking their way up Lower Briggate in a view looking
north from its junction with Call Lane.

The White Cloth Hall in Crown Street, erected in 1774.

Lower Briggate in 1867, with the tower of Holy Trinity Church behind.

The emerging industrial giant was evocatively captured in 1757 by John Dyer, poet of English business. Writing in *The Fleece* he extolled:

'The ruddy roofs and chimney tops:
Of busy Leeds, upwafting to the clouds
The incense of thanksgiving; all is joy.
And trade and business guide the living scene
Roll the full cars, adown the winding Aire
Load the slow-sailing barges, pile the pack
On the low tinkling train of slow-paced steeds.'

Not everyone shared this uncritical view, and in 1756 there had already appeared the first ominous note about Leeds, repeated monotonously down the years. It was sounded by the chief priest of the Gothic revival, Horace Walpole, who came here in that year and dismissed Leeds as 'a dingy large town'. After negotiating 'very bad black roads', he found Kirkstall Abbey more suited to his taste.

Of like mind two years later was the young nobleman who made the unflattering comment that Leeds was 'very large and populous, but exceedingly dirty, ill-built and as badly paved'. He was the third Viscount Grimston, later to become Baron Verulam, bound for Harewood (which he found more appealing). The following year two distinguished visitors came. One, William Hervey, a high-ranking soldier who never minced words, might have been looking over Grimston's shoulder as he brusquely described:

'Leeds ill-paved and not well built, large and populous; went to an orator in the principal church; handsome pillars.'

The other – better known by far – was poet Thomas Gray, who arrived in the same month of October and was even more terse in his judgement: 'a smoky, ugly, large town'. He too was quick to take himself off to Kirkstall, which more readily reflected his disposition.

Unimaginably narrow is the junction of Briggate and Boar Lane as
it was in 1867.

By 1824 another visitor, Hazlitt, was echoing Walpole when he wrote:

'Oh smokey city, dull and dirty Leeds'.

At that time Leeds was in the throes of expansion, which saw it grow from a town of 16,380 in 1767 to a great city of nearly 450,000 by 1911. Over this period its burgeoning industries drew people from the countryside and from across the seas. In 1861, Leeds had an Irish immigrant population of 15,000. Later in the 1880s came the Jews, in flight from the Russian pogroms. At the time a contributor to *The Lancet* wrote:

'. . . at starting they are often acquainted with but one word of English, and that word is Leeds . . . to the Russian Jew . . . the name of Leeds was but a modern term for an El Dorado.'

The pubescent town had still to grow. As a visitor in 1825 observed, it was still 'chiefly composed of one large street with others branching from it. New buildings are formed with an attention to both elegance and convenience, the modern parts being uniform and genteel'.

Could it have been order and gentility that induced HH Prince von Puckler-Muskau to include Leeds in his grand tour of Germany, Holland and England early in the nineteenth century? He was amazed to find that a town with 120,000 inhabitants had no Member of Parliament, whereas 'many a wretched ruined village sends two members'. He reached the town in the twilight and described what he saw:

'A transparent cloud of smoke was diffused over the whole space which it occupies . . . a hundred red fires shot upwards into the sky and as many towering chimneys poured forth columns of black smoke. The huge manufactories, five storeys high in which every window was illuminated had a grand striking effect.'

Yorkshire hospitality has always been legendary and no more so than when it is dispensed in Leeds, so his comments on his reception are a reflection of the custom of the age. Apparently travelling and, on this occasion, dining alone, he was astounded at the repast that was to be his supper/dinner. On his table were:

'A cold ham, an awful roast beef ["awful" probably being used in its former sense of wondrous or full of awe], a leg of mutton, a piece of roast veal, a hare pie, a partridge, three sorts of pickle, cauliflowers cooked in water, potatoes, butter and cheese.'

He was sufficiently impressed to observe that 'this would have been meat enough to feed a whole party of German burghers'.

As a romantic ruin, Kirkstall Abbey attracted the attention of all the artistic visitors to the area, including Horace Walpole and J M W Turner. As one visitor wrote in 1835:

'Ye fortunate neglect of two centuries and a half has spread over ye walls a mantling of ye most luxuriant ivy – while ye aged Wych-Elms, whose roots twine about ye foundations, rear their heads among ye pinnacles, and produce a disposition of light and shade

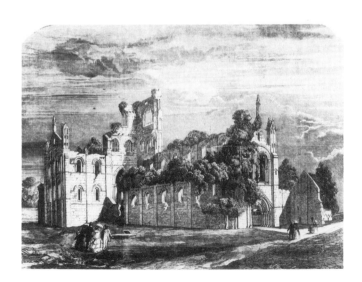

Kirkstall Abbey from an engraving of 1858.

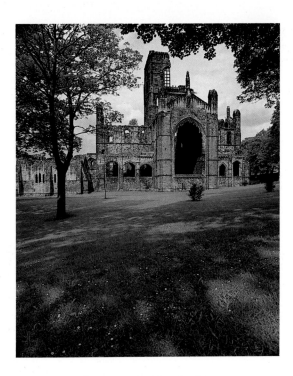

The ruins of Kirkstall Abbey.

which have long render'd Kirkstall a favourite subject for ye Pencil and the graver.'

In fact the vegetation was destroying the ruins, and so following the gift of the abbey by Colonel John North in 1893, the city carried out restoration work to preserve this unique monument.

And by 1855 a commentator felt able to write:

'No ruin is better known or has more examined the skill of the antiquary and artist than this, so that the subject may be said to be exhausted and all said about it that can be said.'

Whilst the gentry went forth looking for picturesque ruins, romanticism and scenic landscapes, Sir George Head was touring the North of England in the summer of 1835 with more utilitarian thoughts in mind. He seems to have visited the great millowners in their place of work. In a significant passage of the book he later wrote, entitled *A Home Tour Through the Manufacturing Districts of England in the summer of 1835*, he makes them out a respectful blank cheque:

'The public . . . have been slow to do justice to the character of the manufacturer, or appreciate the manifold difficulties of his position. Instead of regarding him as an individual on whom hundreds, nay, thousands of his fellow creatures depend for their daily bread, expressions of morbid sympathy have, on the contrary, never ceased to paint the situation of the operatives far darker than it is in reality; while there can be no doubt but that the well being of both parties has been preserved through the struggle, not alone by the industry of the servant, but the benevolence of the master.'

Head appears to have stayed in Leeds not much more than a week. He never returned. Perhaps even local industrial pioneers like Gott and Marshall had more reservations than this about the society the machines and the factories were creating. Their distinguished visitor was especially scathing about interventionist philanthropy – the misguided zeal of men and women who actually pointed out to operatives their real plight. He believed instead in what he called 'the open channels' of sympathy and trust between master and servant, taking it for granted that a servant wanted nothing more than the chance to love his master as his father.

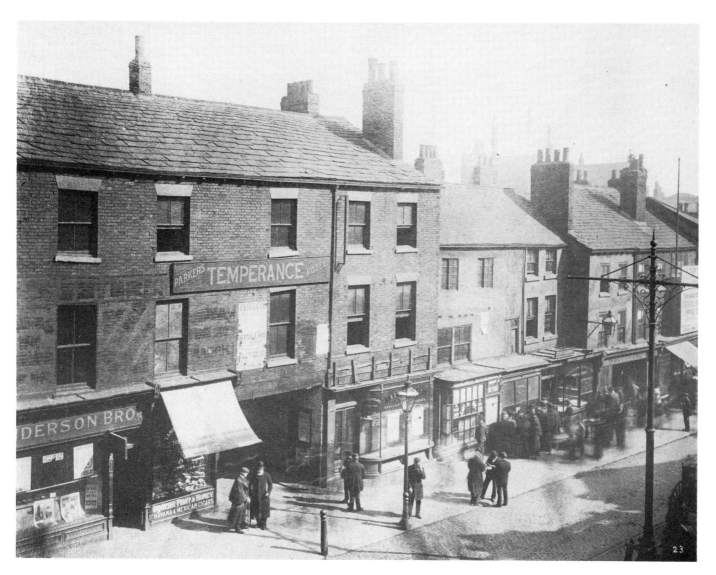

The east side of Briggate about 1897.

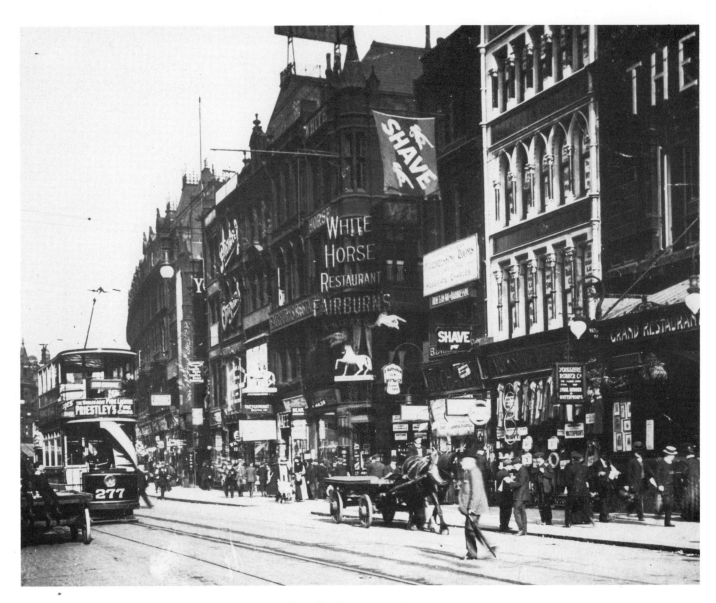

A busy day in Boar Lane in 1912.

Just how unhealthy the rapacious industrialists had made the town and Aire Valley was eloquently portrayed in 1857, when William Osburn in his celebrated lines read to Leeds Philosophical and Literary Society described the river:

'The Aire below is dyed and dammed;
The Air above with lurid smoke is crammed;
The One flows steaming foul as Charon's Styx,
Its poisonous vapours in the other mix.
These sable twins the murky town invest,
By them the skin's begrimed, the lungs oppressed.
How dear the penalty thus paid for wealth
Obtained through wasted life and broken health.'

Eight years later a visitor walking up the Aire Valley near Kirkstall observed:
'The green and variegated hills were shaded on one side by pleasant villas and clusters of trees and on the other side gradually rose and stretched themselves into a vast perspective – the summits propping up the sky; yet, even here, tall chimnies sent up high curly masses of smoke, while in the distance large iron works continued to emit columns of fire to parody the sun with a lurid glare.'
On the other hand Alfred Barnard, writing in 1889 in his book *Noted Breweries of Great Britain and Ireland*, expressed the view that:
'Few manufacturing towns have finer buildings or prettier suburbs than Leeds. Handsome villas and mansions are built on the different roads and around the margins of the park-like moors, and picturesque suburbs rise in beautiful undulations northwards.

Leeds, the most opulent and populous town in Yorkshire, is the seat of the woollen manufacture in England, and contains some fine streets. Among them is Briggate, one of the broadest, handsomest, and busiest thoroughfares in the north of England.'
Attractive as this may sound, it proved no incentive

to at least two famous actresses of the day. In 1807, Mrs Siddons decided that 'rather than lodge in Leeds, most disagreeable town in His Majesty's dominions, God bless him', she would be accommodated at a Kirkstall inn 'for the advantage of pure air and perfect quiet'. She was not stirred, either, by the abbey, which she considered 'too sombre for a person of my age'.

The Star and Garter apparently lived up to expectations, as it did for Mrs Jordan who stayed there in January 1810. She found it 'beautifully situated but its great recommendation is its being so very private'. She was so comfortable there she was reluctant to leave it for Leeds, but she had to be near the theatre when performing. When she came the following year she had not changed her mind, being still enamoured with Kirkstall and hating Leeds more than before; the rusticity of the abbey was 'quite beautiful'. She liked to walk to Leeds by the riverside as a relief from having to stay in the town, where 'to sleep is impossible, the beds are so bad and so dirty'.

The complaint was echoed by Shelley's friend T J Hogg, who passed through Leeds early that same year. 'To see Leeds again, it is said, is to like it less than before', he commented, but he had seen it so often that he could now revisit it without any increased aversion.

The metamorphosis of the city was still in progress, even in 1896 when an observer could write:
'Leeds is a vast business place. When one enters the city from either station, huge warehouses, large shops, big public houses, and signs of active business meet one's view. Leeds is a miniature London, and Boar Lane and Briggate is nearly as busy as London Bridge.'

Imagine, then, the wide-eyed wonder of the twelve year old boy who lived in Wiltshire and came on a visit to stay with relatives here in the 1980s. He afterwards wrote to the *Yorkshire Evening Post*:
'I never knew that when I came to Leeds the buildings were topped by cupolas. This, I thought, was merely an industrial city. However, hidden within the

ugly box-type buildings was a city of beauty and full of poetry and architecture.

Today I cut a small slice from the cake of time stored within the great pulsing heart of Leeds and knew that this was from where my forbears came.

As I gazed upon the roofs of the buildings the great lead-covered domes of the cupolas gleamed in the autumn sunshine.

Dominating all was the great spire of Trinity church pointing to the heavens like a great finger.

This was but one day in my life, but I will treasure it in my heart always.'

Amen to that!

Protean Skyline

'Th' man was threshing in th' abba lair and at nooning a' thocht he'd strecken his back, an' when he gat out he saw a hoile under th' abba, and he crept in and fun' an entry and he went doon it and at bottom there was a great houseplace. There were a gert fire blazing on t' hartstone, and in a corner were tied up a fine black horse. And when it seed him it whinnied. An' behind the horse was a gert black oak kist, and at top o' t' kist a gert black cock, an' cock crawed. Th' man said to hissel, "Brass in t' kist, I'll hae sum on 't". An' as he went up to 't, t' horse whinnied higher an' higher, an' cock crawed louder an' louder; an' when he laid his hand on t' kist, t' horse made such a din, an' t' cock crawed and flapped his wings an' summat fetched him such a flap on t' side of his head as felled him flat, and he knawed nowt more till he came ti hissel, an' he was lying on t' common in t' lair, an' never could he find the hoile under the abba again.'

If this tale of popular tradition is to be believed, then the treasure of jewelled croziers and golden crucifixes hidden by the monks of Kirkstall Abbey still lies in some subterrananean vault waiting to be unearthed.

Discovery of the abbey site was doubtless a welcome relief for Abbot Alexander and his twelve Cistercian monks, who in 1147 had sought to settle at Barnoldswick on land given by Henry de Lacy. But the climate and people proved hostile so Alexander moved on. Whilst passing through Airedale he came to a rather pleasant part, unproductive of crops but with plenty of timber, stone and water – unfortunately inhabited by hermits. The estate belonged to William de Poitou, vassal of Henry de Lacy, to whom a direct appeal was made for the land. He granted the request and Alexander persuaded the hermits to accept the incomers, who erected their first temporary buildings on the 19th May 1152. The monks then began to build their great stone monastery dedicated to the Virgin Mary, where according to legend Alexander and Henry de Lacy were both interred. Their monument was the biggest building of any kind in the immediate vicinity; a major civil engineering enterprise which created a church 224 feet long by 62 feet wide.

And yet J S Fletcher in his *Picturesque History of Yorkshire* was baffled by Kirkstall. He recorded:

'Probably no religious foundation in England had a less eventful history than that of Kirkstall, and its story serves to show that whatever good purposes some of the conventional establishments served, there were others which appeared to have no real reason for existence.'

He was searching for something to say about an abbey which has the most austere of all monastic architecture. With the Dissolution of the Monasteries in 1539 the last abbot, John Ripley, lived in the gatehouse until his death in 1568, and was responsible for its conversion into a dwelling house. The abbey was pillaged and the tower collapsed into the nave in 1779. The same year Thomas Butler leased the estate from the Earl of Cardigan, from whom it was bought in 1890 by Colonel John North and presented to Leeds Corporation. The dramatic ruins, grimly rearing skywards like a spiritual chimney to Heaven, are the city's proudest inheritance.

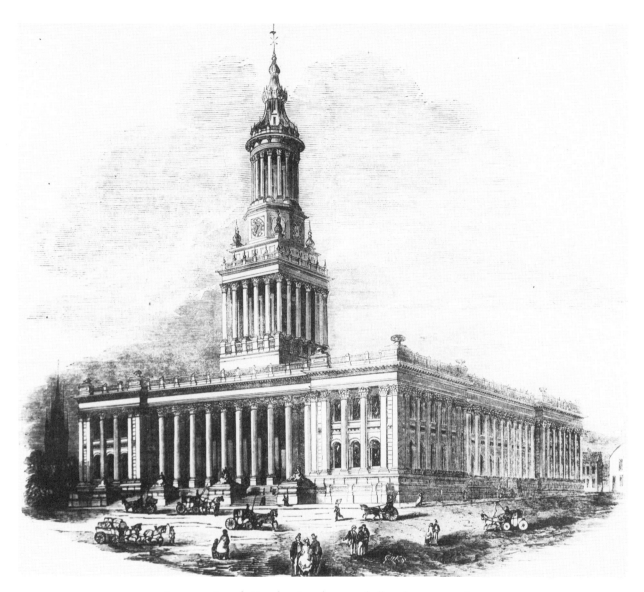

An engraving of 1853 showing the town hall under construction.

Equally spectacular but significantly more influential is the town hall, opened on the 7th September 1858 by Queen Victoria and Prince Albert – an event which brought a knighthood to Mayor Peter Fairburn, fortune and fame to an unknown architect called Cuthbert Brodrick and immense prestige to the city.

The foundation stone had been laid on the 17th August 1853 by Mayor John Hope Shaw, after which a crowd estimated at 200,000 were regaled by the madrigal and motet society with the specially composed chorus:

'A blessing we ask on the work now begun,
May it prosper in doing – be useful when done;
May the Hall whose foundations thus broadly are
 laid,
Stand a trophy to Freedom – to Peace and to Trade;
While within it, may Honour for ever preside
Over those whom opinion may chance to divide:-
And in ages to come may the fabric we rear,
Be greeted, by men yet unborn, with a cheer.
May Justice and Mercy, enthroned in the Law,
Here the innocent shield – keep the guilt in awe:-
May our councils be governed by wisdom and right,
And be open as day, and as pure as its light.
After labour is sped, here the "million" may throng.
To be soothed and refined by the spirit of Song.
Thus in ages to come, shall the fabric we rear
Be greeted, by men yet unborn, with a cheer.'

Cuthbert Brodrick was twenty-nine years old when his classic blueprint won for him the £200 prize in open competition to design the building. It appeared to justify one of its most enthusiastic advocates' claim that 'in the ardour of mercantile pursuits the inhabitants of Leeds have not omitted to cultivate the perception of the beautiful and a taste for the fine arts'. And when it was completed, a Park Lane chemist was so enthused he perfumed the air outside his shop.

The opening also was marked by the first Leeds Music festival, which began with Mendelssohn's *Elijah* and finished with Handel's *Messiah*. The Queen inspected an assembly of 32,110 children watched by 60,000 adults on Woodhouse Moor, for which – in an age as disciplined as the Victorian – it is amusing to learn that the equivalent of the modern television studio floor managers were recruited. These 'signalmen' were there not to control unruly crowd behaviour, but to direct reactions by brandishing boards on which were printed instructions such as 'Prepare to cheer', 'Sing', 'Silence' and 'Dismiss'.

To round off the occasion, Queen Victoria and 272 other guests were entertained to a celebratory banquet, with a menu designed – if nothing else – to confirm that Leeds hospitality could not be found wanting. It included 20 quarts of turtle soup and 20 of clear soup, beef, veal and ham, 5 game pies, 2 boar's heads, 20 lobsters, 9 turkeys, 17 boiled and 17 roast fowl, 12 brace of grouse, 36 brace of pigeons and 20 brace of pheasants. Specially imported fresh pineapples, grapes, peaches, apricots, apples and pears were offered for dessert. And to wash it all down were 114 decanters of the best hock, champagne, claret and other wines.

Certainly Mayor Peter Fairburn spared nothinng to show how much he appreciated the sovereign's visit. In short, he paid for the lot. Every last morsel and every drop of wine came out of his pocket, and it was a tidy sum for more than a century ago – £237 3s.

The structure itself cost about £130,000, with the tower, which has twenty Corinthian columns, added as an afterthought in 1856. Its dominance has the effect of diminishing the size and grandeur of the rest of the building, reducing it to the subsidiary role of a base to carry the tower. Overall it is 250 feet long by 200 feet wide and 225 feet to the dome, with four lions by sculptor W D Keyworth at the front which were added in 1867. Decorating the main entrance arch is a sculptured frieze by John Thomas, with figures

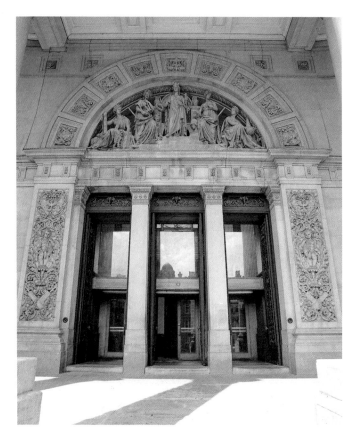

This striking frieze decorates the entrance to the town hall.

The ornate splendour of Victoria Hall inside the town hall.

representing poetry, music, industry, fine arts and sciences seen receiving inspiration from Leeds.

Inside is a domed vestibule with decorations marking the four continents and intended to symbolise the might of the British Empire. The centrepiece of the interior is undoubtedly Victoria Hall – originally the 'Great Hall' – which seats 1,681. The capitals of its giant supporting columns contain the civic owl and golden fleece, with various coats of arms and mottos around the frieze like 'Weave Truth with Trust', 'Honesty is the Best Policy', 'Good Will towards Men' and the progressive injunction 'Forward'. Reminders of freedom and justice are 'Trial by Jury' and 'Magna Carta'. Even neighbouring Bradford's civic motto *Labor Omnia Vincit* is included.

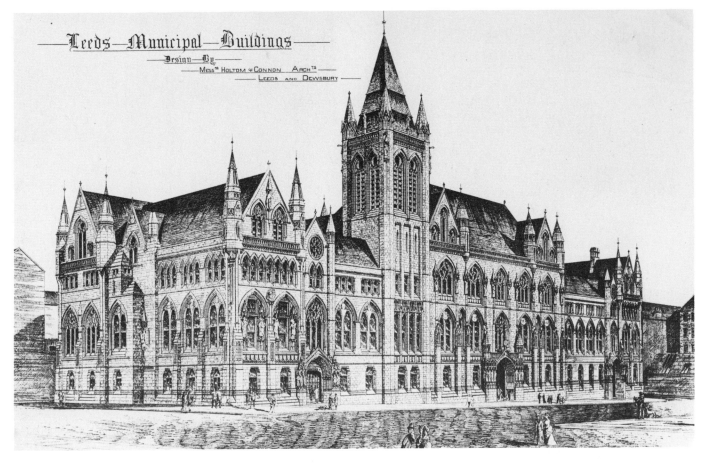

The municipal buildings, opened in 1884.

Across Calverley Street, as if in supplication to the great bulk of the town hall, are the classically designed municipal buildings, surrounded by iron railings surmounted by owls. Created by George Corson and opened in 1884 at a cost of £120,000, the Palladian style harmonises with the town hall, but the interior has coloured tiles, stained glass and wrought ironwork competing for attention. The main features are twin staircases with open arcades, which enable the other staircase to be viewed across the central hall. The marble balustrades of the staircases are decorated with animals – lions and very lifelike dogs.

Standing on higher ground behind the town hall, looking out over Nelson Mandela Gardens, is the civic hall. Building started on the 1st October 1930, to be officially opened on the 23rd August 1933 by King George V (a bust of whom by William Reid Dick dominates the staircase in the entrance hall). The stately front with its portico and six columns is flanked by twin towers, 170 feet high and topped by two giant owls. These gilded birds are 7 feet 6 inches high and each weighs half a ton. Projecting from each tower is a golden clock with tortoises round the dials.

A timeless treasure and landmark in every sense is St Pauls House, named after a demolished Georgian church which stood on an adjoining site in St Pauls Street. Built in 1878 for clothier John Barran to a design of Thomas Ambler in what is known as Arabic-Saracenic style, it is topped by minarets with an ornamental quartrefoil parapet and octagonal turrets. It is a landmark in the history of the clothing trade, having been the first planned and designed clothing factory.

John Barran came from London to Leeds in the 1840s and realised it was an ideal manufacturing centre, especially as the sewing machine had just been perfected and new types of cloth were coming on the market. He pioneered the mass production of ready-made clothing by overcoming the problem of the sewing machine, always beating the cloth cutters. He adapted a veneer cutting machine he had seen exhibited in 1858, and by using this for cloth cutting he even ran into a shortage of labour. An acquaintance, Herman Friend, suggesting recruiting skilled workers from Russia, which resulted in many Jews coming to live in Leeds and further developing the clothing trade. The building was completely modernised in 1977 to provide 68,650 sq ft of office space inside the warm pink brickwork with its elaborate terracotta decorative features.

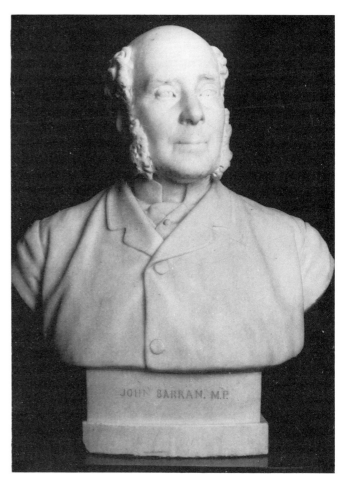

A bust of the nineteenth century clothing magnate John Barran.

The civic hall from Nelson Mandela Gardens.

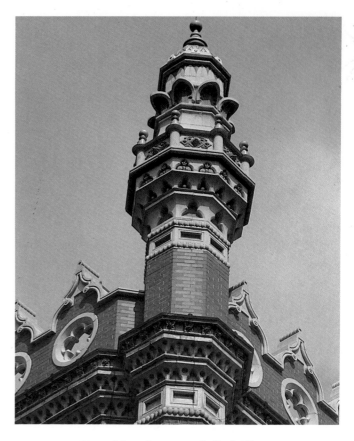

One of the minarets on St Pauls House.

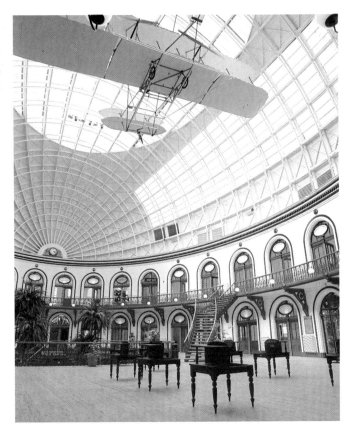

The spacious interior of the Corn Exchange.

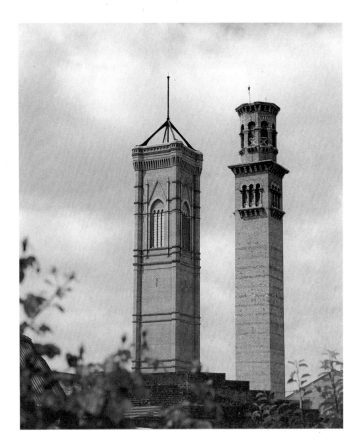

The Italianate chimneys of Tower Works.

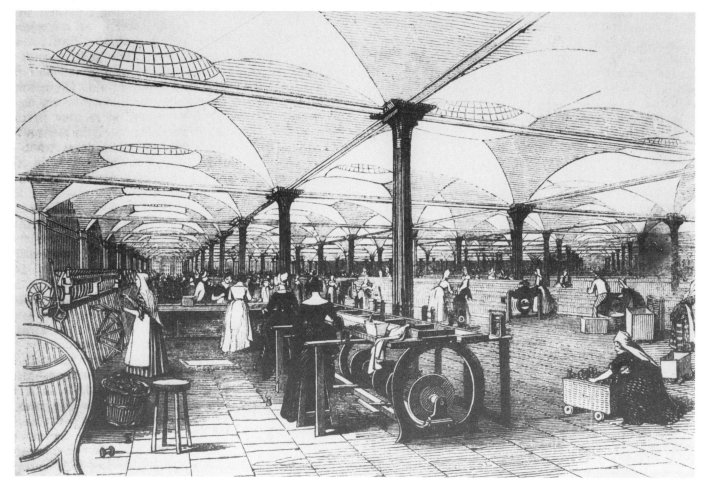

The interior of Marshall's flax mill.

But this was not the first unusual building to grace the Leeds skyline. In 1787, John Marshall had inherited the fortune of £9,000 which his father made in the drapery trade, and as he later recalled:

'My attention was accidentally turned to the spinning of flax by machinery, it being a thing much wished for by the linen manufacturers. The immense profits which had been made by cotton spinners had attracted general attention to mechanical improvements and it might be hoped that flax spinning, if practicable, could be equally advantageous.'

With this in mind, in 1840 he commissioned Ignatius

Bonomi (who had been in Egypt in 1824–33) and David Roberts (the prolific painter of cathedrals and author of books on Egypt) to build Temple Mill, just south of the present City Station. It was a replica of an Egyptian temple, and is reputed to have cost £250,000. Some say the temple of Dendera was the model, others claim Karnak or Edfu.

The outside columns were surmounted by lotus flowers, the inside staircase railings were bullrush-shaped, the office furniture was carved with hieroglyphics; and the mill chimney was, naturally, shaped like Cleopatra's Needle (although it mysteriously disappeared sometime later). Even then Mr Marshall wasn't finished. The flat roof had sixty-six glass domes to light the workshop beneath. Marshall had earth spread between them so grass would grow. Then he put a flock of sheep up there to keep the grass short. Unfortunately the sheep kept falling through the glass domes and getting mangled by the machinery down below.

This curious building – now in the service of a mail order company – has for company in nearby Globe Road the two unique chimneys of Tower Works, which until 1980 was a pin-comb manufacturing business. The earliest chimney, built in 1864, was based on the great Lamberti Tower in Verona, modified to its more prosaic purpose by Thomas Shaw. This was overshadowed in 1899, when William Bakewell created a huge copy of Giotto's fourteenth century marble bell tower of Duomo in Florence, to serve as a second chimney in the same factory. This red-brick tower, with its gilded panels behind the traceried bell-louvres, was ingeniously made to form part of a dust extraction plant in the industrial process. At its base is the boiler house designed as a tribute to famous textile engineers, its white-tiled walls decorated with large portrait medallions by Alfred Drury.

Built like a covered colisseum, with an elliptical

Temple Mill, built by Ignatius Bonomi and David Roberts for John Marshall.

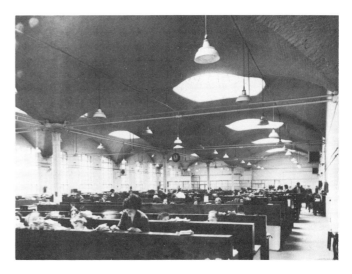

An interior view of flax spinning in Temple Works.

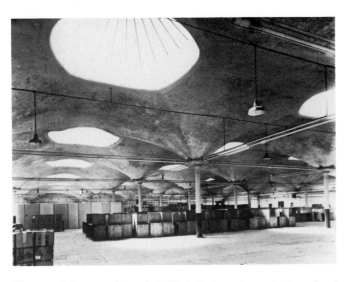

The novel domes at Temple Mill, built into the vaulted roof and supported by cast-iron columns, provided abundant natural lighting.

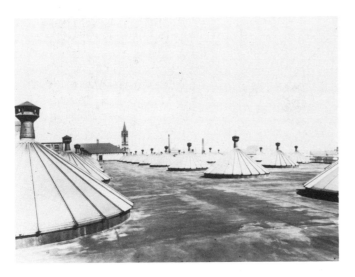

Some of the sixty glass domes built into the roof of Temple Mill to provide illumination in the workshops.

dome 75 feet high and a strongly-modelled facade with diamond-patterned stonework similar to the Palazzo di Diamante at Ferrara, is the Corn Exchange, designed by Cuthbert Brodrick. Opened in 1863 at a cost of £26,000 to replace an older exchange of 1827 at the top of Briggate, it appears to be circular but is in fact elliptical on an area barely equivalent to fifty-four square yards between Call Lane and Crown Street. Yet it is 190 feet long by 136 feet wide, and 86 feet high inside. Under the lightness and elegance of the great dome is at one end a large clock framed in giant gold sheaves of corn, and at the opposite end a colourful representation of the city coat of arms.

Although the Leeds horizon is punctuated from many directions by high-rise office blocks and flats, the most dominant and immediately recognisable feature is the great tower of the university's Parkinson Building. When the Yorkshire College of Science took in its first students in 1874, they had the choice of departments teaching mathematics, experimental physics, chemistry, geology and mining, and textiles. Classics, English, history and French were added within the next three years, before it became a constituent college of the new Victoria University of Manchester. In 1904 a charter was obtained permitting Leeds to become a university in its own right, which was followed by a considerable increase in the number of subjects taught, a growth in the number of students and an expansion in acreage occupied by new buildings (which are said to include the longest straight corridor in Europe).

Impetus for the burgeoning university came from 'old boys' of the former Yorkshire College; men like Frank Parkinson, the then chairman of electrical goods manufacturers Crompton Parkinson and Company. In 1937 he supplemented a previous £50,000 scholarship donation with a further gift of £200,000, to build an imposing entrance which would leave an indelible impression on the minds of those fortunate

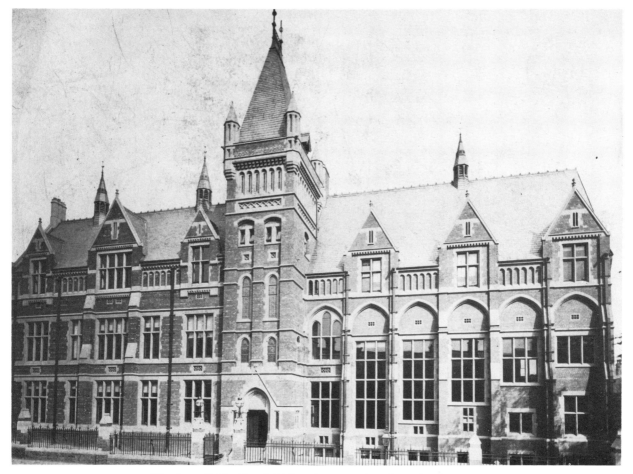

The Great Hall of Leeds University, opened on the 15th July 1885.

enough to study there. It is this central block which bears his name.

A stone frieze depicting items used in arts and sciences carved above the ornately-tiled doorway identifies the Leeds Mechanics Institute in Cookridge Street, designed by Cuthbert Brodrick in 1865. The pavilion roof, huge arched central doorway and heavy stone plinth on which the building stands suggest a strong French influence in the design. It originally contained a large auditorium for lectures and entertainments (now the Civic Theatre), as well as a library, reading room, art gallery and meeting rooms.

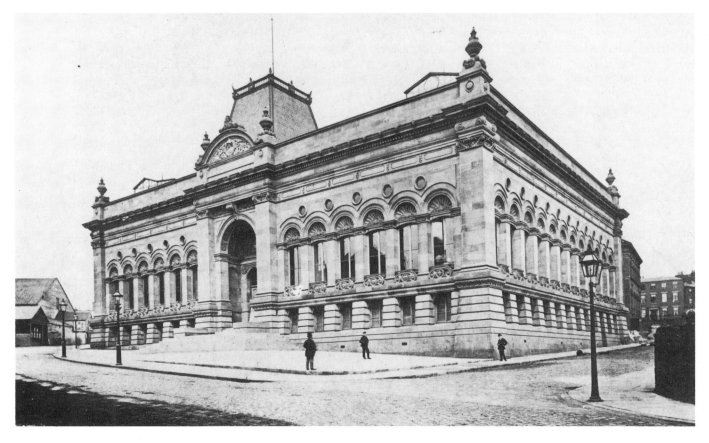

The former mechanics institute is now the Civic Theatre.

The Institute of Sciences, Arts and Literature was born in a house in Park Row during the 1820s, when Leeds was still a town of about 50,000 people. Benjamin Gott was the first president, and the objective of the organisation was defined as:

'To supply at a cheap rate to the different classes of the community, the advantages of instruction in the various branches of science which are of practical application to the various trades and occupations. Such instruction cannot fail to prove of important use to every working man; and the scientific instruction which will give a more thorough knowledge of their arts will greatly tend to improve the skill and practice of those classes of men who are essentially conducive to the prosperity of this large manufacturing town.'

Among the famous guest speakers who addressed

members were Lord Palmerston, Charles Dickens and Admiral Fitzroy. The organisation had developed into the Leeds Mechanics Institution and Literary Society when the new £30,000 building was opened by the mayor in 1868. Seven years later, HRH the Duke of Edinburgh (son of Queen Victoria) opened the Yorkshire Exhibition of Arts and Crafts here, which attracted 640,000 visitors.

Dominating the skyline in Boar Lane is Holy Trinity Church. It was erected in 1726 at a cost of £4,563 to the designs of William Halfpenny, a carpenter from Twickenham whose real name was Michael Hoare, and who is best remembered for his builder's pattern books rather than for his buildings. The site was 'Widow Sleigh's Kidstack garth' bought for £175. A basilican edifice of Black Moor stone in Doric and Corinthian style, its spire is 180 feet high, of which the upper portion was rebuilt in 1839 by R D Chantrell to replace storm damage in January 1838. The real door on the left of the south front was confusingly balanced for the sake of symmetry by a false door on the right.

But it did not impress famous architectural historian Sir Nikolaus Pevsner, who concluded that 'the only church in Leeds of more than local interest' was St John the Evangelist in Briggate, a superb example of seventeenth century Gothic architecture. It was the gift of John Harrison, a former mayor who owned vast estates in the area when the church was completed in 1634. A portrait by an unknown artist and a simple monument inside commemorate Harrison, but of special interest is a stained-glass window that shows scenes from the benefactor's life. One shows him standing in the cloth market (where he made his fortune), apparently urging a poor old man to enter the almshouses which he also endowed; and another shows him directing the master builder who erected this church. Of particular interest is one showing a Roundhead guarding the door of a room whilst John

John Harrison talking to merchants in one of the colourful stained-glass panels of a window that commemorates him in St John the Evangelist Church.

Harrison secretly offers Charles I a tankard. Legend has it that John knew the king's coffers were empty, and after gaining permission to take the captive sovereign a tankard of wine, the resourceful John filled it instead with gold, which the king hurriedly hid in his clothing. Intricately-carved pews were built to hold 600 workpeople, and of unique interest is the hand-wrought iron mace-holder attached to one of the front pews by the pulpit. The town mace was brought to the church each Sunday, the original one weighing sixty-two ounces. The glory of the church is its abundance of oak woodwork, and a gabled roof with a decorated plaster ceiling adorned with flowers and birds. The moulded beams have golden bosses and rest on painted angels with golden wings. The most celebrated section of the woodwork is the five foot wide screen which separates the chancel from the nave. The lower portion is of heavy oak panelling; above is open arcading with finely carved balustrades and lace-like inserts, surmounted by a carved frieze of hearts, rosettes, vine leaves and grapes, broken by grotesques of heads and lions. The screen is crowned by strap-work designs which carry the coats of arms of James I and of Charles I as Prince of Wales.

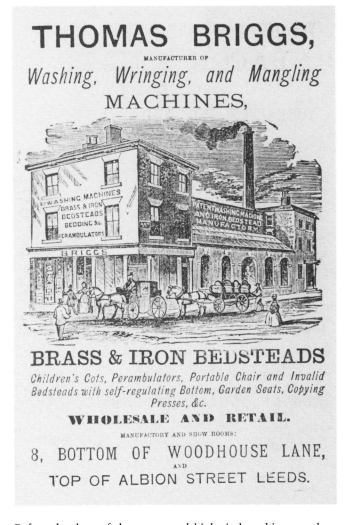

THOMAS BRIGGS,

MANUFACTURER OF

Washing, Wringing, and Mangling MACHINES,

BRASS & IRON BEDSTEADS

Children's Cots, Perambulators, Portable Chair and Invalid Bedsteads with self-regulating Bottom, Garden Seats, Copying Presses, &c.

WHOLESALE AND RETAIL.

MANUFACTORY AND SHOW ROOMS:

8, BOTTOM OF WOODHOUSE LANE,

AND

TOP OF ALBION STREET LEEDS.

Before the days of detergents and biological washing powders, there was a need for tough hardware to tackle the problem of getting rid of industrial grime from clothing. This advertisement highlights the demands of the era.

If 'Cleanliness is next to Godliness', then many Leeds folk were undoubtedly heathen, because for them the electrifying story of industrial expansion had a sombre reality.

They were appallingly overcrowded. No fewer than 341 people were living in 57 rooms in Boot and Shoe Yard in Leeds in 1837. It was from this same notorious yard that seventy cartloads of manure had been removed in 1832. (Boot and Shoe Yard survived into the next decade, when it was demolished to make way for an extension to Kirkgate Market.) The yard was not exceptional. Mid-Victorian Leeds was a filthy place, its air thick with smoke and its streets deep in sewage. As late as 1872 there was a report of a six feet deep middenstead in Wellington Yard, into which fell a slightly inebriated man, plunging deep into the revolting filth; there, suffocating, he lay until discovered by scavengers several days later. Not surprisingly, perhaps, 293 houses were demolished here on the recommendation of the medical officer, for Wellington Yard (near Wellington Street) had been involved in every epidemic since 1832. Another report told of:

'Three parallel streets, which are neither sewered, drained, paved or cleansed . . . occupied entirely by cottage dwellings, with cellar dwellings to boot, for a population . . . of 386 persons, there are but two simple privies, and these in such a state as to be totally unavailable.'

Improvements came slowly. A freshwater supply from Eccup arrived in the town in 1842; before that time, the only piped water was obtained by pumping from the polluted River Aire near Leeds Bridge to two reservoirs in Albion Place and the site of the Grand Theatre.

The provisions for the supply of water in case of fire were even more ludicrous. In 1818 an announcement was made, stating that:

'The commissioners of the water works have

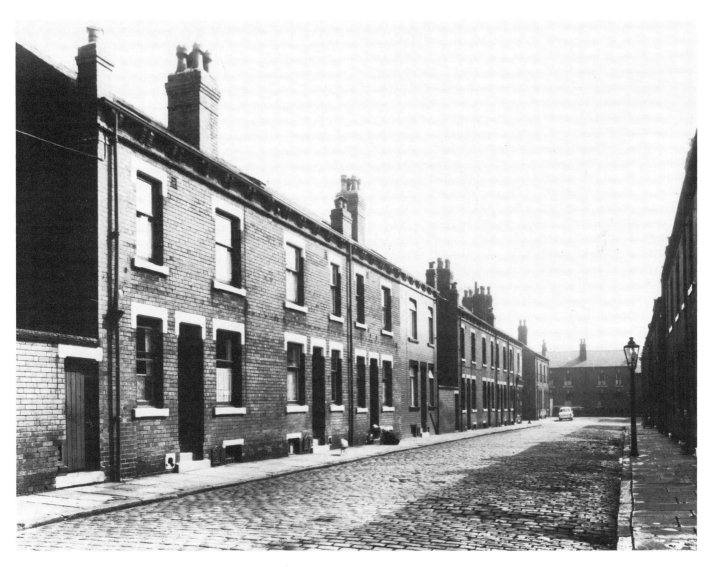

Back-to-back houses in Cedar Place.

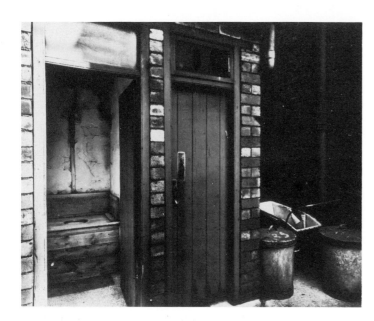

The typical privy, coal house and refuse facilities of a back-to-back house.

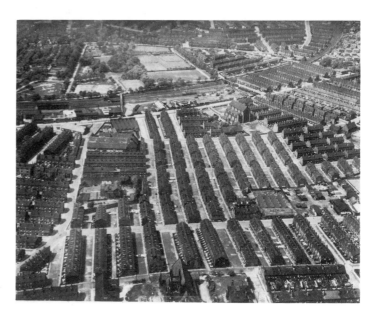

An aerial view of rows of back-to-back houses in the Cardigan Road area.

unanimously agreed that the inhabitants have full liberty in all cases of fire, that may happen where the service of the water pipes extend, to dig down to the pipes, in the most convenient situation, and to cut the same through with a saw, which may very easily be done, as they are of lead.'

How the water was to be conveyed from the main to the fire and what would happen during the process, may be left to the imagination!

Since the river also served as a sewer, it is small wonder that between 1851 and 1860, out of 100 children born in Leeds, 19 died before reaching their first birthday. Horrifyingly the peak was reached as recently as 1893, when twenty-one per cent of children died in their first year.

Should they survive they were condemned to toil long hours for little pay, children representing a substantial proportion of the 9,500 workforce in the Leeds flax mills of the mid-nineteenth century. One consequence of the population boom was a demand for housing. Memorably described as 'the pride and despair of Leeds', back-to-back houses had been introduced in the eighteenth century, and as recently as the thirty years prior to 1914, some 40,000 back-to-backs were built.

The original and worst back-to-backs were simply one up and one down fifteen foot square cottages; and although later ones were larger with bigger rooms in shorter terraces, their construction was a source of constant dispute. As one writer observed during a Governmental enquiry into the sanitary conditions of the labouring classes:

'To build the largest number of cottages in the smallest available space seems to have been the original view of the speculators.'

Back-to-backs were undoubtedly the characteristic domestic architecture of Leeds, and when an Act of Parliament in 1909 banned them 'except in streets already approved', Leeds used this neat loophole to continue building them until 1937. In consequence the city found itself with slum ghettos.

This particular challenge was met with a massive slum clearance programme greater than that of any other comparable city. Typical were the 'York Street Insanitary Free Area' and 'Quarry Hill Unhealthy Area', demolished to make way for new flats. The two areas encompassed a total of nearly 67 acres, on which were 2,790 houses served by an astonishing 53 pubs. A total of 2,147 houses displacing around 9,060 people had been demolished by 1930.

The process of slum clearance created what for many years was the city's most famous landmark, Quarry Hill Flats, not only for its great bulk – it was the biggest block of council flats in Europe – but also for its revolutionary concept. Town planners, architects, builders and housing managers from all over the world hurried through the huge parabolic arch that marked its entrance as they came to inspect this experimental civic development, inspired by housing estates of the twenties and thirties in Vienna and Berlin.

Standing on a twenty-six acre site at the eastern end of the Headrow, the flats consisted of 938 separate units ranging from 4 to 8 storeys high, housing over 3,000 people. Designed and built between 1934 and 1940, this was one of the first high-rise, high-density housing estates to try to preserve the sense of community, being built around an open precinct with play areas and gardens, providing a 'lung' for fresh air and relaxation. The first completed section was opened on the 30th March 1938 by the Lord Mayor, Alderman J Bradley. Eventually less than a fifth of the area was built on, yet it had a shopping area, laundry, day nursery, playground, shops and banks (a social centre and sports area were never completed). There were lifts to all floors, and for the first time in this country a refuse disposal system from the kitchen of each flat direct to a central incinerator, which also provided

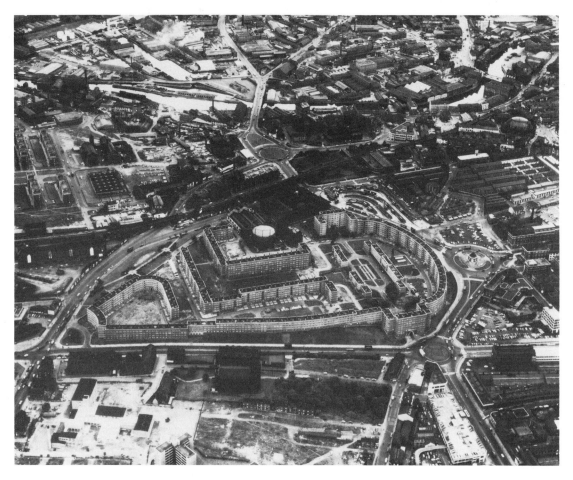

An aerial view of Quarry Hill flats.

heating for the central laundry.

Original, too, was the construction method, using light steel frames and concrete facing slabs. But inevitably there were disadvantages. When the novelty of innovation receded it became apparent that structural faults caused damp and erosion, demanding repairs which continued to escalate in cost, whilst the surrounding landscaping had degenerated into wasteland. The flats also became the haunt of some less desirable citizens of Leeds, a canvas for graffiti and the fuel for vandalism. So in 1978, after a life of less than forty years, Quarry Hill came to an ignominious end under the bulldozers of the demolition contractors.

Just as the mass-production housing of the workers made a dramatic impact on the Leeds horizon, so did the new residential districts for the emergent, upwardly-mobile wealthy, who wished to escape from the smoke and smell of the areas they had themselves overbuilt.

Residential squares were developed on the west side in the eighteenth century. The 'Park Estates' were the first to be developed – Park Row from 1767, South Parade from 1778 and East Parade from 1785 forming the basis of the first squares. Park Place was developed in 1778, with views over fields to the River Aire. The development of Park Square followed – enhanced afterwards by the addition of a statue of Circe, the witch-goddess of Homer's *Odyssey*. She is reputed to have turned men into swine, and three of these animals feature with her in the sculpture created by Alfred Drury in 1895 and brought here from the stable yard of Temple Newsam.

Was the sculpture a sniping comment on the merchants, clergy, lawyers, surgeons, mayors and aldermen who lived here? Now largely offices, these big red-brick houses, in a green oasis garlanded with trees, are a reminder of the age of elegance when – like now – they were very expensive.

Yet there was no shortage of demand, so Queen Square was developed in 1806. Hanover Square was laid out in 1827 in the grounds of Denison Hall, the three-storeyed pedimented mansion which was the home of one of the city's wealthiest families. Three years later Woodhouse Square was developed in the grounds of Little Woodhouse Hall; and Blenheim Square – laid out about the same time – was the last of the Georgian squares, creating a legacy which today is the envy of many a city.

Responsible more than any other man for changing the profile of the city, creating its new fortune and destroying in it the very grace and harmony he aspired to, was industrialist Benjamin Gott. He sought to recapture this idyll of a landscape unsullied by industrial pollution, with horizons unbreached by obtruding buildings and chimneys, when in 1804 he purchased the Manor of Armley. This included the plain house of about 1781 built on a bleak hilltop by local merchant Thomas Woolrick. Between 1810 and 1822, Gott transformed the house and its landscape to the highest standards.

He commissioned Sir Robert Smirke, architect of the British Museum, to enlarge the house in neo-Grecian style. Its walls were hung with paintings by Titian, Rubens, Breughel, Canaletto and other masters, whilst fine marbles from the fifth century BC were displayed with more recent works, such as busts of James Watt and John Rennie by Chantrey.

Before the improvements, this hilltop was so bare and bleak that 'the wind from the moors, along the vale of Kirkstall, would rush through the small vestibule [of Armley House] with such violence as to render it hardly habitable'. To remedy this situation and to provide a suitable setting for the house, Gott brought in Humphrey Repton – the foremost landscape designer of the day – to remodel the whole surrounding park. Repton planted thick woods along the top of the ridge. These, together with new drives, gave:

'The view of an interior lawn, surrounded by woods, the more extensive views shown under the branches of trees, which form an appropriate foreground to the distant scenery, increase the imaginary extent of the place, by showing it partially; and display its scenery by degrees, and in succession.'

The success of this scheme is there for all to appreciate and enjoy in the Gott's Park of today, although the magnificent prospects up the valley to Kirkstall and down the valley to Gott's Mill at Armley are now largely obscured by later planting.

For magnificence and grandeur in Leeds, there is no better example than Temple Newsam House, set in a

large park on the eastern flank. This remarkable Tudor-Jacobean mansion, where Lord Darnley, husband of Mary Queen of Scots and father of James I, was born, came into the hands of the city fathers in 1922. For the nominal sum of £35,000, the house and 917 acre park was bought from Mr Edward Wood, later Lord Halifax. A magnificent carved staircase, great hall and long gallery are among the most admired features of the mansion, which dates from the 1520s, although much of it is as it was left by Sir Arthur Ingram, who bought it in 1622 and enlarged the old house.

Round the top of Temple Newsam is Sir Arthur's declaration of piety and loyalty, carved in letters eighteen inches high:

'ALL GLORY AND PRAISE BE GIVEN TO GOD THE FATHER, THE SON, AND HOLY GHOST ON HIGH; PEACE ON EARTH, GOOD WILL TOWARDS MEN; HONOUR AND TRUE ALLEGIANCE TO OUR GRACIOUS KING; LOVING AFFECTION AMONGST HIS SUBJECTS; HEALTH AND PLENTY BE WITHIN THIS HOUSE.'

Good health was very much on the mind of Leeds surgeon William Hey (1736–1819), whose initiative played a major part in the opening of the first infirmary in a house in Kirkgate in 1776. During the forty-five years he practised here, he gave numerous courses in anatomy using for dissection the bodies of criminals executed at York. In 1809 one such body was that of Mary Bateman, 'the Yorkshire witch', who was executed for the wilful murder of Rebecca Perigo by means of a poisoned pudding.

Infirmary Street is a reminder of a second hospital founded by Edwin Lascelles, first Lord Harewood; the architect was John Carr, designer of Harewood House. For the third infirmary, originally part of the present one, the building committee were advised to consult Gilbert Scott, who opined that 'some form of

The X-ray room at the infirmary shown in its infancy in 1905.

A rather bleak but busy surgical ward at the infirmary about 1899.

The imposing splendour of Temple Newsam.

An elegant staircase in Temple Newsam.

Architecture founded on the Medieval styles but freely treated would meet the requirements of such a building better than any other style'. They had already been assured that 'If Gilbert Scott will undertake the plan he will do it well'. So he was appointed in 1862. In red-brick Lombard Gothic, he built the first hospital on the 'pavilion' plan – which provided cross-lighting and ventilation in the wards as had been advised by Florence Nightingale – and across the centre of the building was a cast-iron and glass winter garden. The conception was hailed as 'perfect ... calculated to place it in the foremost rank of European Hospitals'. In stark contrast is the Portland stone frontage of the later Brotherton Wing, given by Charles Frederick Ratcliffe Brotherton (1882–1949), nephew of the first Lord Brotherton. Its semicircular open balcony ends were optimistically planned for fresh air cures as in the Swiss Alps, but denied through the advent of the motor car and other pollution. Some windows even have imitation shutters modelled into the walls.

Had the intentions borne fruit, it might have inspired an avalanche of 'wish you were here' postcards – but that would have posed no problem because by then Leeds had got itself a permanent post office. In the early part of the nineteenth century there was no public building serving that purpose. The post office was simply attached to the house of the postmaster, with consequent frequent removal. At one time it was in Call Lane, at another it was in Mill Hill adjoining the Griffin Inn. The old court house in Park Row was bought for £6,000 in 1859 and converted into a post office, but demolition of the old Coloured Cloth Hall provided a site for new buildings. Designed by Sir Henry Tanner in Renaissance style, they were opened on the 18th May 1896. Overlooking City Square, the frontage consists of a centre arcade of five coupled Ionic pillars, wholly surmounted by a clock tower and lantern. Twin figures representing 'Reading' and 'Writing' languish over one entrance, whilst 'Reading'

The former Coloured Cloth Hall, which was demolished to make way for the General Post office.

and 'Philosophy' meditate above the other. Four figures on the second storey facade – which appear to have been additions to the original plan – are thought to symbolise Time, Air, Light and Earth.

Perhaps an allegory of Leeds?

Workshop Of The World

Once the world's largest woollen mill, Armley Mills now houses the Leeds Industrial Museum – a collection depicting the city's industrial past with working water wheels, locomotives, textile and printing machinery, and a 1920s cinema.

Situated where the River Aire takes a sweeping curve around a narrow plateau, they occupy one of the best sites in the whole of West Yorkshire for harnessing water power – a feature which doubtless influenced clothier Richard Booth when he leased the 'Armley Millnes' from Henry Savile shortly after the Dissolution (1535–40). By 1707, the Casson and Moore families owned what a document of 1707 described as:

'That fulling mill in Armley known as Casson alias Burley Mills containing two wheels and four stocks with the mill house there unto belonging . . . also the water corn mill and all the fulling mills adjoining under the same roof of the said corn mill containing one wheel and two stocks.'

By the 1750s the mills had passed into the estates of the Hortons of Chadderton, who leased them to John Walker of Armley in 1772.

Traditional methods of domestic cloth production now began to change due to growing mechanisation. Women and children used to convert the locks of wool into light, fluffy 'rolags' by working them between small bat-shaped hand-cards fitted with thousands of short wire hooks. By utilising a series of rotating cylinders fitted in the same way, the scribbling machine (adopted from the cotton industry) completed the same operation with a considerable saving in time and labour, the wool emerging as a continuous flossy sheet.

Confirmation that this was one of the earliest

The sombre works of Benjamin Gott on Wellington Street, which gave way to the modern buildings of Yorkshire Post Newspapers.

woollen scribbling mills in Britain is evidenced by the *Leeds Intelligencer* of the 5th February 1788, advertising for sale or lease 'All those Capital, Ancient and well accustomed Fulling-Mills, Scribbling-Mills and Corn Mills called . . . Armley Mills', with their 'plenty of water and convenience for erecting a number of Mills thereon that no Situation in the West Riding of Yorkshire is superior if any equal thereto'.

Attracted by this unrivalled potential and perhaps bored by his retirement into the squirearchy, former Leeds merchant Colonel Thomas Lloyd acquired the mills for £5,250, and promptly set about a major rebuilding and expansion scheme to make them the largest woollen mills in the world.

A new fulling mill – powered by five parallel waterwheels each 20 feet in diameter and 5 feet wide – took advantage of better water supplies made possible by the engineering work of John Sutcliffe from

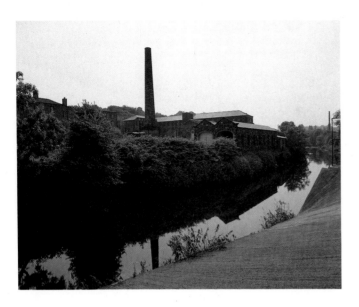

Armley Mills reflected in the waters of the Leeds and Liverpool Canal.

In the above Mills there are no less than 18 Stocks of various sizes & different constructions; so that we may fairly venture to affirm that 50 Pieces of Woollens may be on the Looms today & be milled & upon the Tenters tomorrow.'

During the rebuilding a new corn mill, with eight sets of stones powered by a separate waterwheel, was erected. This was kept by Colonel Lloyd, whilst he leased the fulling mills to Israel and John Burrows. Fire completely destroyed the corn mill in 1790, but by 1797 it had been rebuilt and the lesson learned; a fire engine was bought in 1801 for use at the mills. Alas, four years later on the 20th November it proved totally inadequate when, despite the determined efforts of local villagers and men from the Leeds Volunteer Infantry (of which Colonel Lloyd was commander), the entire fulling mills were destroyed. Only the corn mills and a warehouse remained intact, an embryo for another major rebuilding and a springboard for its owner – Benjamin Gott. He was to become one of the most significant and innovative figures in the history of the woollen industry. As Gott's obituary succinctly put it:

'No-one in the West Riding stood higher as a man of business. He possessed large stores of information, a vigorous intellect, a remarkable decision of character, and a fine taste. No man was ever more regarded or esteemed in his circle than Mr Gott.'

Youngest son of John Gott, an engineer and county surveyor of bridges, Benjamin was born at Calverley near Leeds on the 24th June 1762. By New Year's Day 1780, he was apprenticed to Leeds woollen merchants Wormald and Fountaine for a premium of £400, paid by his father. Both senior partners died, and by 1790 Benjamin had become head of the firm – an opportunity he seized in 1792 by beginning to build the world's first woollen factory at Bean Ings in Wellington Street, on the banks of the River Aire between Armley Mills and the centre of the city. It was

Halifax. Some idea of the magnitude of the rebuilding work can be gained from the valuation of the property: it had risen to £25,200 by 1790, while the rental had increased tenfold to £1,400. Lloyd's zeal was eagerly welcomed by the trustees of the Mixed Cloth Hall in Leeds, who in 1790 announced:

'Fully sensible to the great Advantages likely to arise to the Manufacture of Broad Woollen Cloths by the very compleat manner in which the Fulling Mills in Armley are now finished . . . [we] thank Thomas Lloyd Esqr. for the great expence he has incurred in the erection of so arduous an undertaking and the accommodation his Fulling Mills will render to a part of the Manufacturing Country, hitherto so much distressed for the want of such convenience that the Clothiers in a dry season were often compelled to go eight or ten miles and sometimes even more to get their cloth milled.

to be powered by the largest and most powerful beam engine ever built at that date.

Gott also enjoyed civic prominence, being elected Mayor of Leeds in 1799 – a fateful year, for on the 11th August his Bean Ings Mills were burned to the ground.

Undaunted, he rebuilt Bean Ings and in 1804 entered an agreement to buy Armley Mills, but before the purchase was completed the disastrous conflagration of 1805 razed the latter to the ground. Yet another rebuilding had to take place – this time incorporating improvements in waterwheels, fire-resistant materials and other refinements. As Humphrey Repton noted in 1810 when he saw the new complex:

'I must here compliment the good taste of the proprietor on the unaffected simplicity of this large building which looks like it is – a Mill and a Manufactory; and is not disguised by Gothic windows, or other architectural pretensions too often misapplied by way of ornament. It can never fail to be an interesting object by day light, and at night presents a most splendid illumination of gas light.'

Despite gas lighting still being in its infancy, Gott realised that it was far safer than the generally used oil-lamps and candles.

Once again Leeds clothiers had the services of a modern scribbling and fulling mill, which also provided excellent working conditions for the 57 men and 121 women who laboured there. Nevertheless, horrific accidents occurred through largely unguarded machinery, as a newspaper account of 1882 testifies:

'On Saturday week, Geo Dyson, a boy about 13 years of age, while employed in filling a carding machine at Armley Mill, unfortunately got entangled in the machinery, by which accident his thigh was severed from his body, and he was in other respects so dreadfully injured as to occasion his death shortly afterwards.'

Paradoxically, it was the Bean Ings Mills that were to be the Gott's great achievement and his Achilles

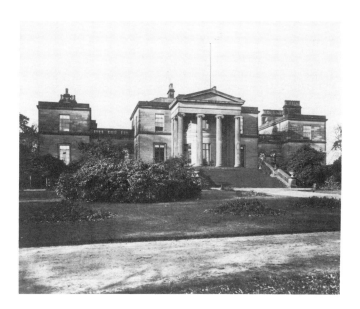

Armley House.

heel. The mills produced excellent profits, enabling Gott to amass a large fortune, make improvements in his mills, undertake charitable works, patronise the arts and to purchase the Manor of Armley. Here he was able to have his park landscaped and convert the former Armley House into an outstanding fireproofed Grecian villa, containing a fine library and an art collection which included classical Greek antiquities, Old Master paintings and specially-commissioned works of contemporary artists.

The penalty for this affluence was pollution and the price was prosecution. Gott was indicted on the 14th April 1823 with causing a nuisance by allowing his Bean Ings Mills to emit 'noisome and unwholesome smokes and vapours, so that the air at Leeds was impregnated with the said smokes and vapours, and was rendered and became greatly corrupted, offensive and unwholesome'. The case was moved from Leeds to

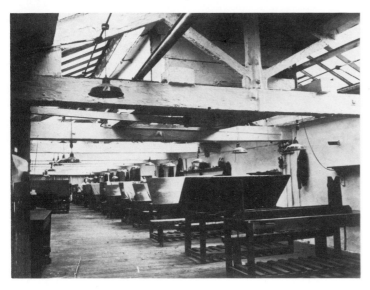

An interior view of Bean Ings Mills before demolition.

York Lent Assizes in 1824. By this time Gott had done much to alleviate the problem, but he clearly wished the trial to go ahead – doubtless to demonstrate his annoyance with the emergent 'middle class' who lived around Park Square, the most affected area. The trial transcript reveals:

'Mr Gott – a person described to me as a most valuable member of society, in all the relations of life, and a man of the highest honour and credit – had done much to abate the nuisance. But the old gentleman is testy about this prosecution. He considers it as a somewhat officious interference with his private concerns, and is therefore angry with us for prosecuting; and you will be a little surprised on learning, that, in consequence of the alterations he has made since this indictment was preferred, there has been a communication sent to him, and a notice given, that the proceedings would be suspended on certain terms. (Here the learned Serjeant read a letter addressed to the Defendants, by the prosecutors, in which they proposed to suspend further proceedings, if the former would pay all the costs already incurred. He also read the answer of the defendants, rejecting the proposal, and stating their intention to try the case at York). It is the defendants who have brought the case for trial to York. Here we are, not because the inhabitants of Leeds have not been annoyed for the last twenty years, but because this respectable old gentleman is angry with the prosecutors, and sets them at defiance. That is the reason we are here today.'

Benjamin Gott died in 1840 and his sons carried on the business. But time took its toll and Bean Ings Mills were demolished in the 1960s, providing the site for a strong new landmark thrust up against the busy Leeds skyline – the home of Yorkshire Post Newspapers Ltd. Officially opened on the 10th December 1970 by HRH the Prince of Wales, the £5,000,000 project provided presses forming the largest hybrid press installation in the world. When they went into action on 28 September 1970, producing the *Yorkshire Post* and *Yorkshire Evening Post* for the first time, they became the first in Britain to combine web offset and

traditional letterpress processes simultaneously.

The statistics of the new building are daunting. Nearly 20,800 tons of poured concrete and 220 tons of structural steel went into a building of 20,000 square feet. The huge 160 feet long and 105 feet wide press hall is dominated by four press lines each weighing some 300 tons, which annually gobble up about 110,000 miles of paper. Newspapers were both progeny and promoters of industrialisation in Leeds. The *Leeds Mercury* was founded in 1718 and, after failing miserably between 1755 and 1767, enjoyed a modest success before being acquired in 1801 by the twenty-seven year old Preston-born printer Edward Baines. For almost a century he and his family were to be major figures in Leeds, with both he and his son Edward becoming Members of Parliament. Edward senior was captivated by the sovereignty of the millowners, whilst his son was besotted with Liberalism. In the course of their ownership, the *Mercury* campaigned for reform of the old parochial system of local government, the establishment of the Leeds Savings Bank, provision of public baths and the start of the temperance and literary societies. In the process, Baines became an absolute treasure-house of information about business and trade, which resulted in the publication of a massive two volume *History, Directory & Gazeteer of the County of York* in 1822. All this whilst he was engrossed in editing, politicking and rearing eleven children!

But the field was not left entirely to Baines, for on the 2nd July 1754 Griffith Wright printed the first issue of the *Leeds Intelligencer* – and there was evidently no love lost between the two papers. In the 1830s it commented on Baines senior:

'The portly proprietor of the *Mercury* – the sexagenarian dandy of Briggate – the Solon of Leeds Workhouse . . . the Demosthenes of Hunslet – is still the same poverty-stricken adventurer he was thirty years ago when he came into Leeds . . . his head as

Two pages from a promotional folder for newspapers controlled by Edward Baines & Sons Ltd.

Newspaper production at the Yorkshire Post Newspapers building.

The junction of Park Row and Bond Street was the setting for the country's first electric traffic lights.

empty of ideas as his back was bare of clothes.'

Rallying the materialising middle class, the *Intelligencer* chronicled the Industrial Revolution and sharpened itself by intense competition with its rival. In 1866 the *Intelligencer* was transformed into the *Yorkshire Post*, and the battle heightened in September 1890 with the birth of its offspring – the *Yorkshire Evening Post*. The coming of the *Evening Post* was foreshadowed in 1879, when the interest in the trial of Charles Peace at Leeds Assizes reached such fever pitch that a special evening issue of four pages was published on the 4th February, containing a full account of the one day hearing (which resulted in Peace being sentenced to death).

By 1923 the battle was over. The *Mercury* was acquired, and the two rivals ran from the same stable for sixteen years before being merged in November 1939. Since then other newspapers in surrounding localities have been absorbed, culminating in the 1969 merger with United Newspapers Ltd.

Manifesting the solid character of the newspapers is the new building, which won from architect Derek Linstrum the comment:

'As a welcome change from the common-place dull curtain-walled spaces which have been going up in every town and city, the *Yorkshire Post* has commissioned a building that proclaims itself immediately as architecture.'

Recognition of this came with the Royal Institute of British Architects Yorkshire Regional Award in 1971. From the top of its tower, the time of day and temperature flash out alternately at passing motorists on the inner ring road, as if to reassure them that they are in the heart of the city.

Getting up steam on the Middleton Railway.

The modern lines of the Hilton Hotel and office blocks overshadow the terminus of the Leeds and Liverpool Canal in the heart of the city alongside the railway station.

Or perhaps it is a subtle reminder that Leeds may have had the first speaking clock, according to a *Yorkshire Evening Post* item of 1933 about two clockmakers who had for months been engaged on an invention which they hoped to perfect early in 1934. They were Mr W J F Kirkaldy and Mr W J F Macdonald, described as 'members of a famous Leeds clock making firm'. For months they had worked in a small room on the clock which, when ready, would be placed in a soundproof cabinet. It would have a microphone attached and would have its own telephone number. When callers dialled the number the clock would speak the time, though in hours and minutes and not in seconds. Both men said they thought it was a valuable commercial proposition. 'Already many people ring us daily to ask the correct time. Callers to the Post Office also ask for the time so

that our clock would be valuable there as it would cut out the services of an operator', claimed one of the men. Whether in fact they perfected the clock in 1934 is not known, as there are no further reports.

Their employer was probably the famous clock-making firm of Potts. About 1862, William Potts (1809–86) came to Leeds, where three of his sons helped him build a business with an enviable reputation for hand-made public timepieces. Some of the legacy is still to be seen in the city; roundhead wall clocks for railway stations, floral clocks, school, office, works, town hall, cathedral and church clocks were all supplied by the firm, and they even contracted for winding them – no mean feat when in institutions like Leeds Infirmary all the timepieces were wound by hand. In their heyday about 1907, a staff of forty-seven were engaged in clock production, but demand

decreased and in the 1930s the firm was sold to a Derby clock-maker.

There was a time, too, when Holbeck was described as 'a pleasant village quite detached from the town of Leeds and approached through a large tract of meadowland, undoubtedly used for sheep rearing'. It was also named from its low situation and, of course, from the Hol Beck which ran through the village, and which indeed can still be seen in Water Lane.

However, its rural aspect soon changed, and the staple trade of wool was replaced by machinery tools and engineering, mainly due to unlimited supplies of coal being available. This industrialisation was destined to prove a mixed blessing, as the introduction of machinery brought mills and factories. These in turn attracted workpeople, and to accommodate them the millowners built large numbers of small cottages on restricted sites quite close to the factories, for – with at least twelve hour working days – men, women and even little children could not be expected to travel any great distance to their labours. With bad conditions and low wages, there was a good deal of hardship, which prompted a fervent desire to improve their lot, giving rise to the 'Holbeck Societies'.

These early societies were established on the 'terminating' principle under an Act of 1836, which meant that as soon as sufficient funds were on hand, advances were made to members and the society terminated, usually after about twelve and a half years.

The first to be formed was the Leeds Union Operative Land and Building Society, which met in the Old School Room in Marsh Street. This society, which was founded in January 1845 and terminated in 1857, had as its first secretary one Henry Morton, solicitor William Middleton, and as one of the trustees John Bell. Middleton and Bell were the first solicitor and secretary respectively of the present Leeds Permanent Building Society, which was founded in 1848.

The success of the first 'Holbeck Society' was so great that, before it was terminated, it was necessary to found the Second Leeds Union Operative Benefit Building Society in 1852. Before that was terminated in 1864, the Leeds Union Operative Building Society was formed in 1857. The process was repeated with the Holbeck Benefit Building Society in 1864, and the Leeds Union Operative Benefit Society emerged in 1870. The Building Societies Act of 1874 created the framework for the foundation on the 21st January 1875 of the Leeds and Holbeck Permanent Building Society ('Permanent' was removed from the name in 1929). The society prospered, and expanded its assets from £35,000 to £100,000,000 by its centenary. In 1963 a huge new building was officially opened on the Albion Street corner of the Headrow – close to its rival the Leeds Permanent Building Society – serving as a permanent reminder of business foresight and the virtue of thrift long practised by Leeds folk.

Indeed the fable about London's streets being paved with gold might have disappointed fewer Irishmen if Leeds had been substituted for London and coal for gold. As one observer put it:

'Little wonder that with the fuel positively cropping to the surface in the streets the locality was ahead of most of the country in the use of it.'

Parts of Leeds were literally built on coal. An eighteenth century property advertisement offered houses and cottages on land 'supposed to be full of coal'. And with over 4,000 Irish immigrant labourers in the town, the coal industry evolved rapidly.

At first, coal was taken from the surface. Then came bell-pits, mere holes in the ground with no ventilation. As the miners exhausted the potential of one bell-pit (perhaps because the roof had become unsafe), they went on to dig another nearby. Three feet diameter 'bells' were worked in the Calls, and local historian Ralph Thoresby writes of 'pits without number in the vicinity of Leeds'. They spread like a rash – sixty-five

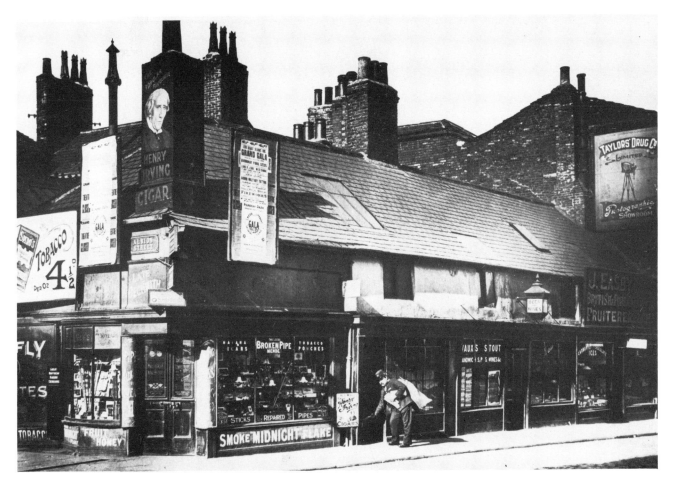

The corner of Albion Street and Guildford Street about 1900, which was the boundary spot marked by Burley Bar and on which now stands the headquarters of the Leeds and Holbeck Building Society.

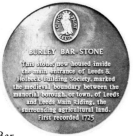

The blue plaque commemorating the Burley Bar.

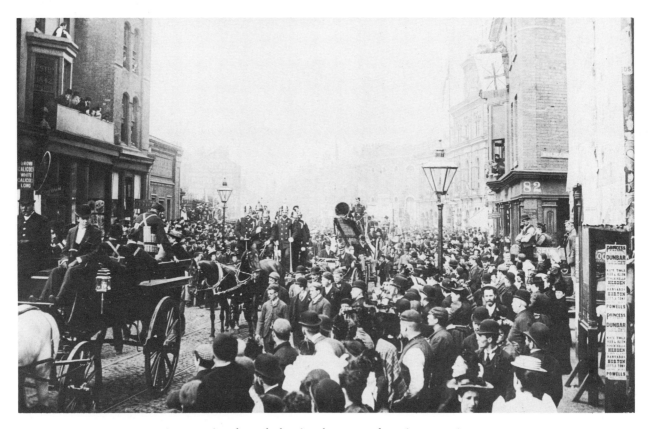

A procession through the city about 1906 featuring a contingent
from the fire service.

of them in the south-west of the town alone and many
more never recorded – so much so that they were a
positive hazard for the unwary; a report in the *Leeds
Intelligencer* told of the misfortune that befell John
Eddison of Armley, who 'missed his way, fell into a
coal pit, and was killed'. The newspaper added the
admonition: 'What a pity it is so many places of the
above kind are, when deserted by the colliery, left
totally unguarded, notwithstanding the numerous
misfortunes that they occasion'.

Mining was not always undertaken by specialists:
the 'getters' and their attendant boy workers called
'hurriers' were seemingly being admitted by
landowners, who issued halfpenny tokens for the use
of 'ye Cole Pits'. It was apparently do-it-yourself coal-
getting: you paid your halfpenny and helped yourself.

The inhabitants of the town were in no doubt as to
the value of the mineral wealth at – and under – their
doorsteps. A farm at Whitkirk was offered for sale
with the additional inducement that there was 'a good
bed of coal for draining whereof . . . a rough or drift is
now open'.

On the 26th July 1906 occurred 'The Great Fire of Leeds' at the Great Northern Hotel in Wellington Street. The fire engine was a 'steamer' – the coal on the ground has obviously fallen out of the coal box. The driver is wearing a flat cap but the rest of the crew have brass helmets.

Inevitably, in the absence of any kind of quality control, there were disputes about supplies, and one of the principal mine-owners, Charles Brandling, had to take steps to defend his product. In 1781 he took advertising space in the *Leeds Intelligencer* to warn:

'... great Impositions have been put on the public as well as Charles Brandling Esq by the Vendors of Coals in the Neighbourhood of Leeds, several of whom have sold an inferior sort to their customers as and for Mr Brandling's coals ...'

Coal was never won without cost. On New Year's Day 1780, firedamp went off with a loud explosion at a pit described as being 'near this town', killing 7 miners on the spot and injuring 3. In January 1825, men and boys were killed in another pit disaster, including a lad of only 5 years, 2 aged 8, 3 aged 10, and 2 aged 12. Without these abundant and cheap supplies of coal, it seems certain that Leeds would not have enjoyed its meteoric rise to economic importance and industrial wealth, becoming a magnet for commerce at the hub of a network of communications.

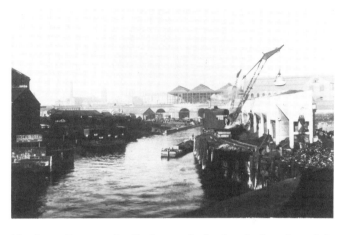

The busy Co-operative Society coal wharf at the junction of the Aire Navigation with the Leeds and Liverpool Canal just above Victoria Bridge.

Coal burning in the home needed an artistic setting and, to pander to the new wealthy white-collar workers, J & H Smith boasted a variety of chimney pieces, of which the new parlour mantel displayed in their advertisement was a typical example.

By Water And By Land

A great cheer went up as the policeman on point duty at the junction of Park Row and Bond Street stopped all four lanes of traffic and went to a control box to switch on the country's first permanent automatic electric traffic lights. The date was the 16th March 1928. Hundreds of citizens lined the streets, with numerous cars, horses and carts, bicycles and even handcarts converging on the attraction. Recalling the occasion some years later, one observer said:

'As I sat astride my father's shoulders, a well-proportioned police sergeant straddled his way down the street. Turning towards the crowd, he authoritatively quipped, "Well – how d'yer like our iron policeman?" Quick as a flash an alert wag shouted, "They're better than wooden ones!" I was too young to understand, but oh, how everybody, including the sergeant laughed and laughed.'

The lights – red, amber and green – were set on eight foot high cast-iron standards topped with a finial, and although the police reported no difficulties they noticed a tendency for drivers to regard the 'caution' light as an 'all clear' signal!

A year earlier on the 24th August, the *Yorkshire Post* had reproduced a sketch of a 'mechanical policeman' invented by a sixteen year old Leeds boy called Leslie Chapman. The young apprentice's master plan, which had taken many hours to conceive and draw, was sold by his mother to the lad's employer. It was subsequently put before the watch committee and seriously considered. The device worked on the basis of four arms revolving on a standard every few seconds according to the regulation of the mechanism, and so opening and closing roads to traffic. On top a clock with a revolving pointer indicated the number of seconds to run before a change. Fortunately his design never reached the manufacturing stage.

Ever since the first charter granted in 1207 enabled Leeds citizens to move the goods they made or bought 'by water and by land, whithersoever they will, without impediment and without paying custom, unless they are forbidden to do so by the lord or his bailiffs', they have taken advantage of this freedom and generally sought to be in the vanguard of transport development.

In 1699 an Act of Parliament had been passed in order to make navigable the Rivers Aire and Calder, linking Leeds and Wakefield with the Ouse, the Humber and the sea – that vital outlet for the export of cloth and other products. Leeds, at the western extremity of the Aire and Calder Navigation, created for itself the role of inland port serving the rapidly-expanding West Riding hinterland. But the condition of the waterway left much to be desired, and when in 1770–1 rumours were voiced of a projected canal from Leeds to Selby, the 'undertakers' of the Aire and Calder Navigation suddenly found themselves fighting for their very existence. John Smeaton – aided by his brilliant protégé William Jessop – were recruited to suggest ways of eliminating the river's troublesome tideway, as the undertakers sought to maintain control. An immense struggle ensued and, after twice being rebuffed by Parliament in 1772–3, assent was finally secured in 1774 for a canal to be dug from the Aire to the Ouse by the shortest possible route. The five mile canal, costing £20,000, was opened on the 29th April 1778, and established Selby as a principal outlet for the Leeds trade.

Meanwhile Leeds had linked itself to the West Coast, for straddling the Pennines like a giant fluid umbilical chord was the Leeds and Liverpool Canal – the longest single canal in Britain. (In its 117 mile journey from the Aire to the Mersey, it climbs 487 feet over the Pennines.) Work started in 1770 when the

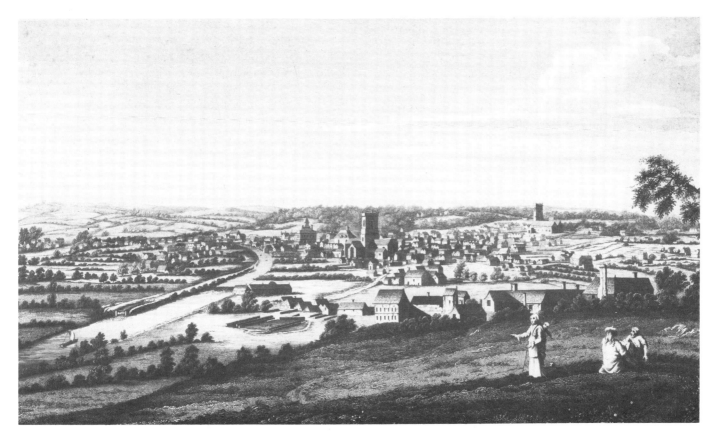

Seen from Knostrop in 1715, Leeds was a tiny place alongside the
River Aire which provided a valuable water highway.

project was authorised by Act of Parliament, but the
whole route was not completed until some forty-six
years later.

By then the Aire and Calder Navigation was
proudly proclaiming that 'Fly boats are despatched
every morning in time for the Steam Packets for Hull'.
Other boats left for London via Leicester; Leeds to
Manchester via Wakefield, Halifax and Rochdale; and
Leeds to Liverpool.

The canals had a tremendous impact in this period,
when the pack-horse and stage-wagon monopolised
inland transport. As the *Leeds Intelligencer* reported
in 1777 on the opening of the first stage of the Leeds
and Liverpool Canal in Yorkshire:

'This noble and grand undertaking now affords the
most safe, easy, cheap and expeditious method of
conveying the produce of different countries to and
from the populous manufacturing towns ... Its

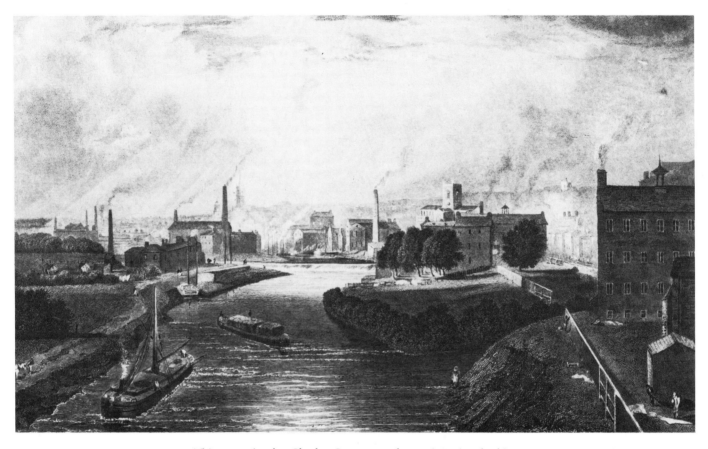

This engraving by Charles Cope around 1830 is a view looking
north-west along the River Aire.

execution hath given employment and bread to the indigent and laborious; drawn forth latent merit; raised genius from obscurity; and improved and advanced Agriculture and the Arts of the extensive and populous parts through which it passes and which it ornaments and adorns.'

The eulogy for the development may be hard to understand in these go-ahead days of inter-city electric trains, bus services and private cars, for it is difficult to picture a town like Leeds as it was three centuries ago, when carriages were comparatively unknown and the principal mode of transit for goods was the pack-horse. And as the uncrowned metropolis for the cloth trade, Leeds lagged behind neighbouring towns for almost half a century before ultimately becoming a great coaching centre. This slothfulness has been largely attributed to the execrable nature of the approaches to the town.

Barges on the Aire Navigation pass under
the new Leeds Bridge about 1898.

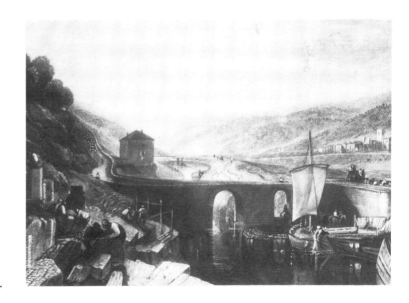

Kirkstall Lock on the Leeds and Liverpool Canal, drawn
by J M W Turner RA and engraved by W Jay.

The solution – although marked with riot, disaster and death – marked the real advent of the coaching era here. A Turnpike Act of 1740 was passed for repairing the highway from Leeds to Selby, the natural outlet for merchandise through Hull. In the same year, acts were passed for improving the road between Leeds and Elland, and for making the Leeds, Bradford and Halifax turnpike road. In 1750 the Leeds to York road was repaired, and the following year another act provided for the northbound route through Harewood, Harrogate and Knaresborough to Boroughbridge. In 1754 came the Leeds and Skipton turnpike road through Otley and – more significantly as far as coaching was concerned – the Leeds, Wakefield, Barnsley and Sheffield Turnpike Act of 1759.

Whilst the ratepayers objected to being saddled with the cost of maintaining roads, the users were equally unwilling to see that tolls were a relatively small price to pay for the benefits gained. Violent resistance to paying was followed by riot and carnage, as armed gangs went about burning the toll houses and smashing the gates.

In June 1753 a remarkable event occurred which became known and dignified as the 'Leeds Fight'. A huge crowd of rioters, armed with every conceivable weapon, sallied forth from Leeds intent on destroying the new turnpike at Harewood Bridge; but Edwin Lascelles, first Lord Harewood, had been forewarned and assembled about 300 hundred of his tenants and workmen. The confrontation turned into a fracas in which many were injured; the rioters dispersed, but thirty of them were taken prisoner.

Mauled but not defeated, the rioters were still smarting from their rebuff. About a week later, tempers boiled over once again when a carter refusing to pay the toll at Beeston Turnpike was arrested by soldiers brought from York. He was rescued by the populace before he could be brought before the

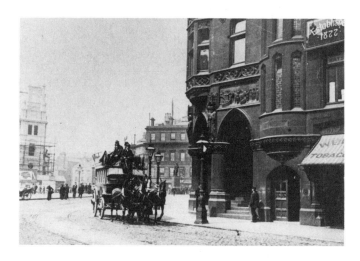

A DILIGENCE
From LEEDS to HALIFAX, MANCHESTER, and LIVERPOOL,
SET out from Mr. HINDLE's, the Rose-and-Crown Inn, Leeds, on Sunday the 21st of May, 1786, at Seven o'Clock in the Morning, and arrived at Mr. BOOND's, the Upper Swan, Market-Street Lane, Manchester, about Four o'Clock the same Evening; and will continue to set out from the above Inns every Morning at the above Hour.

A DILIGENCE also sets out from the said Rose-and-Crown Inn, for YORK and HULL, every Morning, Sundays excepted.

Perform'd by { HINDLE, HARPER and Co.

☞ The Proprietors will not be accountable for any Parcel above the Value of Five Pounds, unless entered as such, and paid for accordingly.

Passengers and Parcels are booked at the Rose-and-Crown Inn, at Leeds; the King's-Arms Inn, at Bradford; and at the Cross-Pipes Inn, at Halifax.

This Rose and Crown advertisement of 1786 tells of trans-Pennine travel before the days of trains and the M62 motorway.

A stagecoach rattles round the corner from City Square into Boar Lane.

magistrates and turnpike trustees, meeting at the Kings Arms in Briggate. Elated with their success, the mob assembled again in the evening, determined to rescue three other prisoners apprehended the night before. They proceeded to break the windows and shutters of the Kings Arms, and to tear up paving stones to throw at the soldiers. The mayor read the Riot Act, but as the rioters had already knocked down the sentinel, the soldiers were given orders to fire – which they did. First they used only powder with the intention of intimidating the crowd, but when this had no effect they loaded with ball, killing 8 rioters and wounding about 40, several of whom died later.

After this incident, the repairing of the old roads made greater progress, and in 1760 the first of the 'Flying Machines on Steel Springs' was advertised to make the four day journey (although it was advertised as three days) between Leeds and London. Links with other centres followed, and by the beginning of the nineteenth century there were nearly forty coaches running in and out of Leeds daily. Within fifteen years that number had doubled, and by 1838 there were 130 arriving and departing from Leeds, making, it would seem, no place too far. Yet travelling in those days was much more expensive relatively than it is today; the fare to London was seventy-three shillings and sixpence inside and thirty-eight shillings outside; the cost of conveying goods was even higher proportionally.

Serving the new mobility were about nine major coaching inns. Most have given way to other developments, but the Griffin in Boar Lane and the Golden Lion in Briggate still remain. In 1834 the Golden Lion horsed Matthew Outhwaite's *Birmingham Telegraph*, which ran in competition with the *Pilot*, the coachmen indulging in racing and all the dangerous tricks and dodges known to accelerate the pace of the horses – and scare timid passengers. One such *Telegraph* driver was Tom Johnson,

whose employer was a leading Methodist in the town. On the occasion of a Methodist conference in Leeds, four ministers made strong complaints of the very violent and dangerous manner in which they had made their journey to attend the conference, and begged Outhwaite to admonish the coachman on the evils of racing so that the return trip was less uncomfortable. 'Now, Tom', said Outhwaite in a loud voice with much ostentation to the coachman before the departure, 'no racing on any account, mind you, or I'll discharge you'. Then going round to the window, he assured the four reverend gentlemen in his most conciliatory manner that they need have no fear, as his coachman was a very careful individual. 'I will speak to him again', he said, and slipping off to the front he exclaimed in an undertone to Tom: '. . . and I will discharge you, too, if you dare to let the *Pilot* beat you to Wakefield!' Needless to relate, Tom carried out his owner's orders in a manner that was very quickly calculated to scare all the good out of them that the old gentlemen had received at the conference.

Coaching died very hard. Railway after railway opened, but still enterprising coach proprietors made efforts to maintain their business by changing routes and even combining services with the new 'iron horse'. But the vast revenues which were formerly derived from the working of a popular stagecoach had received their irrevocable death blow, and the railways gained a firm and permanent footing.

The Leeds and Selby Railway Company had been established in 1829, an Act of Parliament obtained in 1830 and the completed line opened on the 22nd September 1834. Watched by over 20,000 astonished spectators, 160 passengers were pulled along by the steam locomotive *Nelson*, albeit somewhat behind schedule 'in consequence of the axles of the engine being too large'.

Most of the line opened in that year was much the same as the route we know today, but there were one

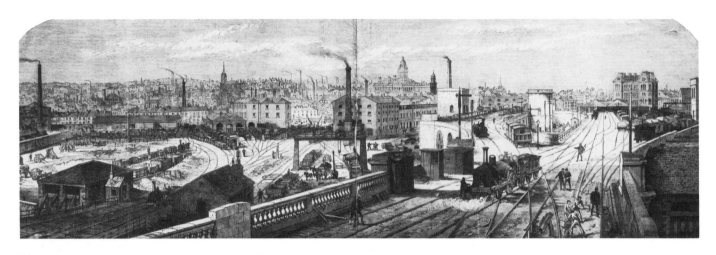

The railway approach to Leeds as seen from Holbeck Junction
before the turn of the century.

or two quite significant differences. The Leeds
terminus was originally at Marsh Lane, although the
company graciously ran an omnibus to the station
from their Kirkgate office, and charged the not
inconsiderable sum of fourpence for the privilege of
riding in this vehicle. The terminus was described as:

'One of the most unpleasant and dirty, but likely to
become one of the most improving parts of the town of
Leeds. The prodigious embankments upon which the
Rail-Road is conducted from the Tunnel will excite the
admiration of the visitor.'

Almost immediately after leaving the terminus, the
line entered the 700 yard long tunnel under Richmond
Hill. This tunnel – long since opened out into a deep
cutting between Marsh lane and Neville Hill – was the

On the south side of City Square stood the old Queen's Hotel and
the Midland Station entrance, seen here in 1931.

The Middleton Colliery Railway about 1829, showing Blenkinsop's locomotive with a 'silencer' fitted adjacent to the chimney.

first in the country through which passengers were actually drawn by a locomotive, and passage through it occasioned terrors of no ordinary kind. One passenger recorded:

'We were immediately enveloped in total darkness and every one of the carriages filled with smoke and steam to a most annoying degree. Though we were but a few minutes going through such was the nuisance we thought it an hour.'

On another occasion, when the train struck some scaffolding in the tunnel, the same passenger wrote that 'both men and women were so alarmed and frightened . . . that they declared their apprehension of immediate death'. The scaffolding had been erected to whitewash the tunnel walls in an attempt to increase lighting and reduce its terrors!

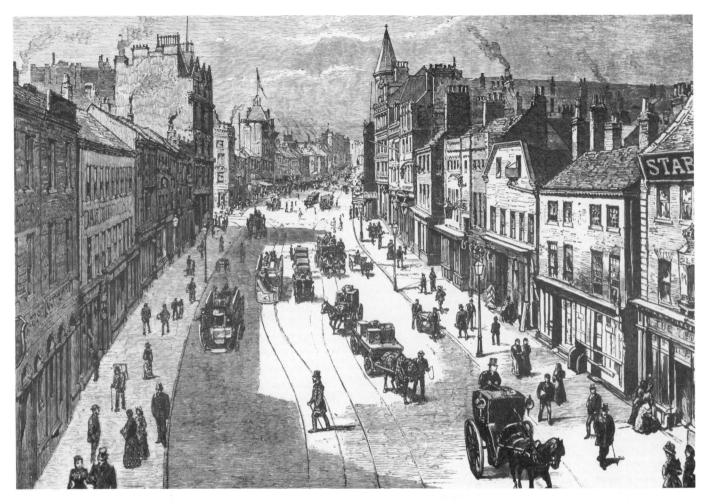

Looking up Briggate from the railway viaduct in 1885.

Despite these traumas, the railway was a great success. In summertime about 400 people had been carried by coach between Leeds and Selby, but in 1835 some 3,500 made the journey by train through 'the waving woods of Temple Newsam and the pleasing plantations of Killingbeck'. The 'awayday' was born and, in the flush of novelty, 779 passengers in the first four days paid either three shillings for a first-class seat or two shillings for an open carriage ride. For the more adventurous, Hull was now accessible by steamer connection on a combined ticket costing only an additional two shillings.

One such traveller was Elizabeth Tetley, who went with her sister Lucy on a week's visit to Hull to attend a music festival, and decided to travel home by the new railway. On the 29th September 1834 she recorded:

'This was the day fixed for our return to Leeds. We arranged to go by the Packet and Railway and therefore took our place thro'. The tides were so bad that we got on ground twice but unfortunately had not long to remain.

We were much pleased with the Railway conveyance tho' we had so much luggage and so many passengers that the engine had not sufficient power to draw us, and they took part of the carriages off and put horses to them which caused those who were first to wait some time up the road until the carriages came, as they did not like to have it said that they did not arrive all together. The stations at Selby and Leeds were in a very unfinished state not fit for passengers. There is great confusion attendant on the arrival of such a number of persons and so much luggage which makes travelling by coach preferable, particularly for ladies. If Railways become general there will be an end to travelling without gentlemen.'

Keen to maximise revenue, the railway company even charged one shilling for a dog, but the real moneyspinner – freight – was still to come.

In 1840 the North Midland opened a station at Hunslet Lane. Leeds and Bradford Railway's Wellington Street Station opened in 1846, while the Manchester and Leeds Railway gave the city its Central Station in 1854. Leeds New Station – jointly owned by the London and North-Western Railway, and North-Eastern Railway – was opened in 1869. In that year, too, was completed the extension of the North-East Line from Marsh Lane, which had been authorised in 1865.

Over the years these early railways were gradually absorbed to form larger units, and by the end of the First World War the city was served by five companies – North-Eastern, London Midland and the Great Northern, with two others, the Lancashire and Yorkshire, and Great Central, having running powers into the city by using other companies' lines.

Amalgamation of railway companies in 1921–3 resulted in two mainline companies – the London and North-Eastern, and the London Midland and Scottish – each serving Leeds. By this time the city had three main passenger stations – Central, Wellington and the adjacent New Station. Englarged on a number of occasions, New Station was joined to Wellington and renamed City in 1938, following extensive reconstruction and the creation of the Queens Hotel to replace an 1863 building of the same name. After an Act of Parliament in 1960, City Station was virtually rebuilt, City House – the tall office block above the platforms – incorporated, and Central Station closed on the 1st May 1967 so that all services could be concentrated at one station. The work, which took seven years, included two bridges over the Leeds and Liverpool Canal, on which the station sits in addition to two roads and the River Aire. A more curious location for a railway station would be hard to find!

Paradoxically, whilst George Stephenson and the dubious George Hudson of York are credited with inaugurating the railway revolution, it really had its genesis in Leeds. The industrial sibling needed fuel to nurture its growth and – in the suburbs of Belle Isle and Beeston – coal was near the surface, making it easily workable. The Lord of the Manor of Middleton, Charles Brandling, obtained an Act of Parliament on the 9th June 1758 to construct a wagonway to be operated by horse-drawn vehicles. This would link his Middleton mines with staithes on the River Aire at Cassons Close near Leeds Bridge, and, although this was a scant three miles, the four foot gauge had a 1 in 20 incline. Never in his wildest dreams could he have imagined the revolution he was unleashing with this first Act of Parliament passed to establish a railway.

In return for the privilege, he promised to deliver into Leeds, for the next sixty years, 23,000 tons of coal a year at four shillings and ninepence a ton – which was about ten per cent cheaper than competing sources. As a result this gave a tremendous impetus to the development of chemicals, glassworks, potteries, brickworks and iron founding.

The system worked well for about half a century, until the price of foodstuffs for the horses prompted the then overseer John Blenkinsop to seek an alternative. His answer was to introduce a rack and pinion railway, which he duly patented. Almost immediately Matthew Murray at his Holbeck works produced a practical steam engine named *Blenkinsop*. The *Leeds Mercury* of the 27th June 1812 stated:

'At 4 o'clock in the afternoon the machine ran from the Coal Staith to the top of Hunslet Moor, 8 waggons of coal each weighing 3¼ tons, were hooked to the back part, and 50 passengers in addition were carried a journey of 1½ miles in twenty minutes. This invention will rank as one of great public utility and will place the inventors among the benefactors of the country.'

Two locomotives – *Salamanca* and *Prince Regent* – were introduced onto the Middleton Railway, and although they only managed to crawl along at three miles an hour they could haul ninety tons. They were cheaper than the horses, as was their 'feed' – the abundant coal that they were hauling.

The gauge was changed to the national standard in 1881, after which the line enjoyed changing fortunes, first becoming publicly owned in 1946, part closed in 1948 and totally closed in 1958. However, within a year the Middleton was reborn to become the first standard gauge railway to be operated by amateurs. Spearheaded by Dr Ronald Youll of Leeds University, a band of enthusiasts set about restoration of the line itself, and on the 20th June 1960 operated their first passenger service, followed by a regular freight service from the 1st September. The Middleton Railway is today run by railway enthusiasts as a working museum. During the week it carries goods for local firms, and at weekends and Bank Holidays a steam-hauled passenger service is operated from Hunslet Moor to Middleton Park. This offers a different prospect to that recorded by Parsons in his *History of Leeds* in 1831. He recorded:

'The general aspect of the place is strangely uncouth, and perhaps a more dismal scene cannot be presented than the tract of mud and marsh called Hunslet Moor on a rainy day.'

Here, in this unpromising environment, history was being made.

In the realms of passenger transport, too, the city played a pioneering role, so that when Edward VII opened the first London electric tramway to great acclamation, the news was greeted with a patronising smile by Leeds folk. Twelve years before, in 1891, a length of line one mile and three-quarters in length had been laid from Sheepscar to Roundhay Park, and down it had run the first electrically-driven tram service in Great Britain.

The Tramways Act of 1870 had given impetus for the introduction of horse-drawn trams, and they were first seen in the town when a short length of track was laid on vacant land in Cookridge Street and the public invited to test the comfort of the new vehicle. The first route to Headingley was established by a private company the following year, and they swiftly introduced further services to Chapeltown, Kirkstall, Hunslet and Marsh Lane. The latter three routes served dominantly artisan areas, from which it would appear the company hoped for substantial traffic. The chairman of the company optimistically pointed out that the working man would see that there was a 'real economy in the saving of time to make a more general use of the tramway car'. Perhaps this was a bit tongue-in-cheek, because his company charged twopence 'short' fares, demanded a further penny to complete

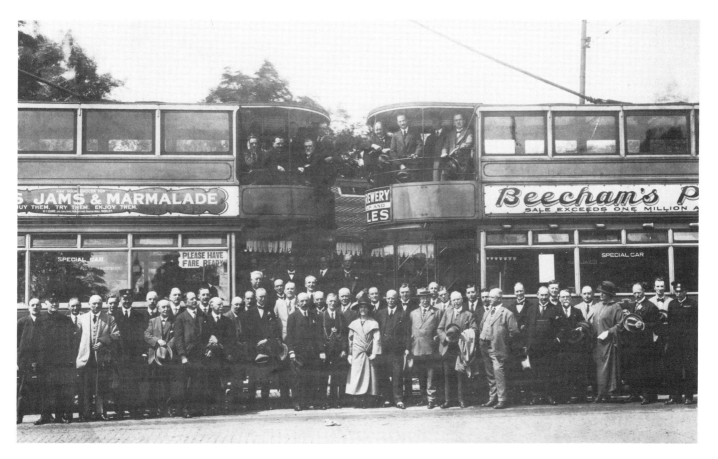

On the 20th July 1923, civic dignitaries and other worthies lined up
for this photograph to commemorate the opening of the electric
tramway between Holbeck and Roundhay.

the journey and ignored its obligation to run early morning workmen's cars at halfpenny a mile fares (minimum one penny).

More routes followed and then steam trams took over, only to be displaced in their turn by electrification. The climax came in 1894 when the

tramways were acquired by the corporation. Fares were kept to the absolute minimum, with a halfpenny stage for short journeys and early morning concessions for factory workers; a two mile journey could be accomplished for just one penny. Neighbouring townships were linked to the tram

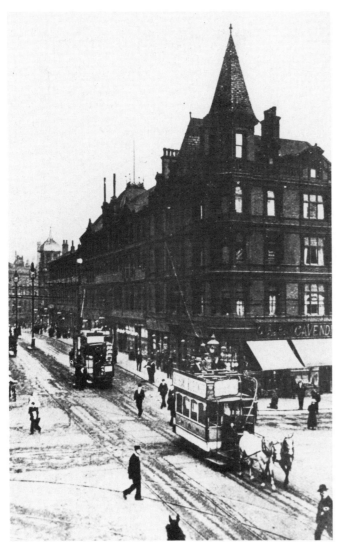

Horse-drawn and electric trams at the corner of Briggate in 1901.

network, and is claimed that it was possible to go all the way by tram to Liverpool, except for eight miles between Hebden Bridge and Summit near Littleborough.

The trams were abandoned in the 1950s, but recently traffic congestion has resulted in a number of proposals for their re-introduction. The renaissance of the tram might well be near. A leading expert on traffic problems recently suggested:

'Old policies should be taken out and dusted off and an assessment made of events elsewhere in the world to see if anything might work for Leeds.'

Exploiters, Enigmas And Eccentrics

Leeds has had its share of men who have made their mark on the city and country, sometimes on the world. Inevitably in an industrial city, the majority have been engineers, scientists and industrialists.

Typical was the invention that enabled great rivers to be spanned, huge buildings erected, vast sheets of water dammed, motorways to be constructed and in a thousand other ways changed the face of the world. Joseph Aspdin was the man and his discovery was Portland cement.

His early life was spent in comparative obscurity, and even the patenting of his world-changing invention aroused public interest only to the extent of one short sentence in the *Leeds Mercury* on the 6th November 1824:

'We hear that Joseph Aspdin, bricklayer of this town, has obtained a patent for a superior cement resembling Portland stone.'

Some authorities suggest his father was a builder in Leeds, but this cannot be verified. Certainly Leeds was only a small town when young Aspdin was apprenticed in the bricklaying and plastering trade. Education was scanty, work was arduous for a pittance in reward, amusements were few and a public demonstration of capital punishment was one of the most exciting events of the year. Not surprisingly, the best outlet for an ambitious boy was the practical aspects of his trade.

Aspdin was probably influenced by the experimental work of the great civil engineer John Smeaton. In those days, industrial development was undertaken without any form of government aid, and a story is told that on one occasion Aspdin was fined by an irate justice of the peace for taking limestone off the roads in

John Smeaton, engineer of the Eddystone Lighthouse, from an engraving published in 1798.

order to conduct experiments. This is probably true, since in his patent specification of 1824 he mentions:

' . . . limestone such as that generally used for making or repairing roads; taken from the roads after it is reduced to a puddle or powder; but if I cannot procure a sufficient quantity of the above from the roads, I obtain the limestone itself, and I cause the puddle or powder, or limestone, as the case may be, to be calcined.'

At the time Aspdin was living at 3 Princess Street, New Road, but he subsequently moved to Wakefield were he died on the 20th March 1855 aged seventy-six, and lies buried in St Joseph's churchyard there.

Leeds keeps alive Aspdin's memory with a plaque on the civic hall, whilst the enduring monument to John Smeaton is undoubtedly the Eddystone Lighthouse, which is depicted in Whitkirk Parish Church on the memorial tablet that commemorates his death in 1792.

'Even while a boy in petticoats, he was continually dividing circles and squares, and the only playthings in which he seemed to take any interest were the models of things that would work', wrote Samuel Smiles in his biography of the engineering genius born in June 1724 at Austhorpe Lodge, the son of a Leeds lawyer. A persistent observer and inquisitor of masons and carpenters, the young Smeaton amassed an encyclopedic knowledge which was to serve him well in later life, but which so puzzled his contemporaries they christened him 'Fooley Smeaton'.

'Thus, it happened', Smiles further informs us, 'that some mechanics came into the neighbourhood to erect a fire engine – as the steam pump was then known – to pump water from the Garforth coal mines; and Smeaton made daily visits to them for the purpose of watching their operations.

Carefully observing their methods, he proceeded to make a miniature engine at home, provided with pumps and other apparatus, and he even succeeded in getting it set to work before the colliery engine was ready.

He first tried its powers upon one of the fish ponds in front of the house at Austhorpe, which he succeeded in pumping completely dry, and thereby killed all the fish in the pond, very much to the annoyance of his father.'

Instead of forbidding such activities, Smeaton's father responded by equipping an outhouse as a workshop for his son's experiments. But on his sixteenth birthday, young John started legal training in his father's office. His thoughts and interests lay elsewhere, a fact recognised by his father who agreed that the young Smeaton should exploit his talents in a more practical sphere. After a spell in London, during which he delivered various addresses to the Royal Society, he was recommended by its president, the Earl of Macclesfield, as the ideal engineer to tackle the building of a third Eddystone Lighthouse. His research made him conclude that previous structures had been too light and this prompted him to build in stone, a revolutionary idea that attracted considerable scorn. But, as in his childhod days, he had conducted various experiments, first at his Leeds home where he erected a combined study, workshop and observatory. The result earned him immortality and a flood of work: the Aire and Calder Navigation; the construction of the Forth and Clyde Canal; bridges at Coldstream, Perth, and Banff; as well as remedial work on the old London Bridge and the drainage of low-lying lands near Doncaster.

A bridge and a workshop figure prominently, too, in the enigmatic story of what might have resulted in Leeds becoming the Hollywood of Britain. If Louis Aime Augustin Le Prince ever looks down on the city, he must be delighted to see that on the very site of his old workshop – where he made a one lens camera and with it photographed the first moving pictures – the BBC have built their Northern television studios. It is

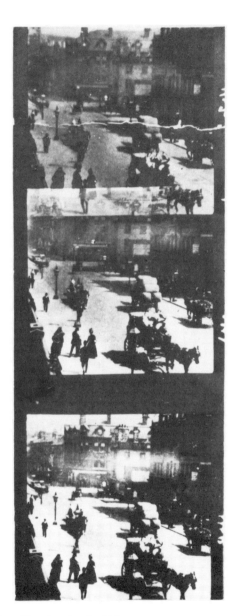

Some frames from the first moving film shot by Le Prince near
Leeds Bridge.

This commemorative blue plaque to Louis Le Prince is on the wall of BBC North, which stands on the site where he did his experimental work.

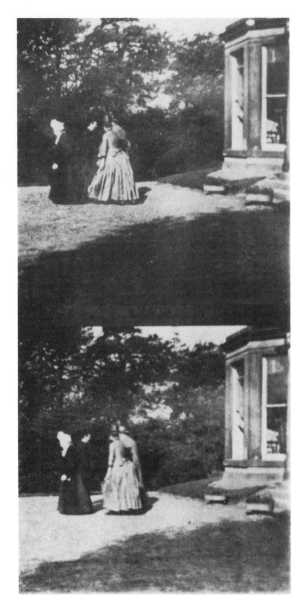

Le Prince's moving pictures filmed in his father-in-law's garden in Roundhay.

a kind of poetic justice, a cry at last from a man who vanished from the face of the earth, and the final fruition of what seemed, when Le Prince disappeared in 1890, no more than a romantic dream. Preserved here is a plaque which records that 'some of the pictures were taken on Leeds Bridge in 1888. He also made a projecting machine and thus initiated the art of cinematography' – in which he was assisted by his son and three Leeds men, Joseph Whitley, James W Longley and Frederick Mason. Le Prince's disappearance on the eve of making a fortune is one of the great unsolved mysteries. With all to live for, in perfect health and in optimistic mood, he stepped on to a train and was never seen again.

Born at Metz on the 28th August 1842, Le Prince spent nearly half of his life in Leeds. His father was a

friend of Daguerre, the pioneer photographer, who gave young Le Prince his first lessons in a subject that became his career. Having left Leipzig University in the 1880s, Le Prince came to Leeds at the invitation of a college friend, John R Whitley. Here he married Whitley's sister and they founded the School of Applied Art in Park Square. Soon afterwards the couple went to America, where Le Prince continued experiments started in Leeds. He made a camera to photograph moving pictures and applied for an American patent on the 2nd November 1886.

Early in 1887 the couple returned to Leeds, where he improved his camera and applied for a British patent on the 10th January 1888. That year, having made a one lens camera, the inventor photographed moving pictures at twelve frames per second in the garden of his father-in-law's home at Oakwood Grange, Roundhay. Then, one bright October morning, he took his movie camera to Leeds Bridge and shot another series at twenty frames per second, recording the first motion pictures of horse-drawn wagons and pedestrians strolling their way into history.

Describing the results, Le Prince's colleague James Longley wrote graphically:

'It was as if you were on the bridge yourself. I could even see the smoke coming out of a man's pipe, who was lounging on the bridge.'

In 1890 he went to France on patent business, and was last seen by his brother entering a train for Paris on the 16th September. From that moment he disappeared. It was if the man had never been, though he stood six feet three inches tall and was a striking figure. Not a scrap of his luggage nor a single one of his business papers ever turned up. A classic mystery without a solution. The void was filled by Friese-Green of Bath, who gets the credit for inventing cinematography; but there seems little doubt that Le Prince's moving pictures were the first to appear on a screen.

Close to where Le Prince shot his pictures, about eight feet above the pavement on the end wall of a building on the south side of Leeds Bridge, is a simple plaque that informs passers-by:

'In 1847 at a meeting place in these premises the "Band of Hope" movement was formed, its title being suggested by the Reverend Jabez Tunnicliffe, a prominent Leeds temperance worker.'

One of twenty-two children born to a Wolverhampton boot and shoe maker, Jabez Tunnicliffe came to Leeds on the 13th November 1842, and gained a reputation for his high principles, oratory and advocacy of abstinence. His urge to set up the temperance movement is evident in a letter he wrote:

'In June 1847 a very melancholy circumstance occurred. I was called to visit a young man named George Paley, aged, I think about 28, whose young life had been poisoned and shortened through habits of intemperance. I visited him several times. The day before his death I entered his room and found him sitting in an arm chair. His wife and children were there too.'

Mr Paley told of being a regular Sunday school goer, but on one occasion he walked a few miles in the country with friends afterwards and they agreed to stop at a country pub for a glass of ale. It became a habit – and on occasional weekday evenings too – as a result of which he gave up Sunday school and became a regular drunkard.

Tunnicliffe reported his experience to some Quaker friends, and the movement was born out of an informal meeting with them. He produced a popular melody: 'Come all ye children, sing a song ... the Band of Hope shall be our name, the Temperance star our guide'. Two hundred children enrolled and pledged: 'I agree to abstain from all intoxicating liquors and from tobacco in all its forms'. The first boy to sign up was twelve year old George Mitchell of 8 Coach Lane, Cornhill, and his brother was second in a movement

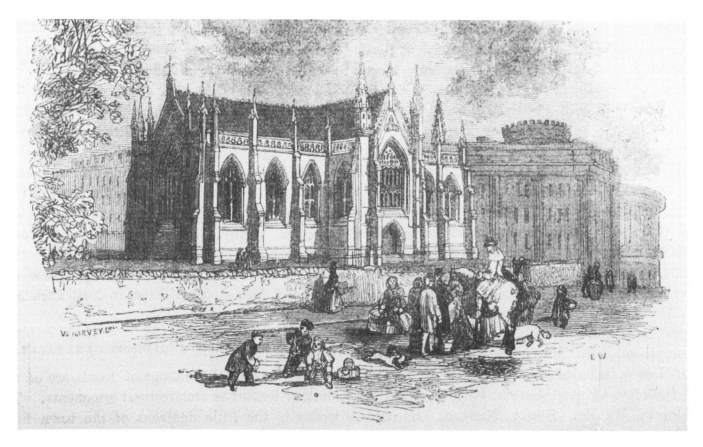

Mill Hill Chapel, where Joseph Priestley preached.

which once boasted 1,500,000 members all over the country.

The unlikely combination of a professional cleric and avid amateur scientist, who relied on friends' generosity for his equipment, was Joseph Priestley, minister from 1767 for six years at the Unitarian Chapel in Mill Hill. He discovered oxygen, or 'dephlogisticated air' as he called it.

At the time, his equipment included a weird electrical contraption, and some of its uses were either less than scientific or add to his probity, if a local tale is to be given credence. Apparently a woman who believed she was 'possessed' appealed to Joseph as 'a great philosopher who could perform miracles' for help. To humour her, he stood her on a glass-legged stool, turned on his electrical machinery and gave her such a shock that she was convinced he had exorcised her demon.

Joseph Priestley, discoverer of 'dephlogisticated air'.

In 1722, Priestley published a paper announcing the discovery of marine acid gas (hydrochloric acid) and nitrous air (nitrous oxide). Ironically when the Copley Medal, loftiest honour of the Royal Society, was presented to Priestley, it was not for his discovery of oxygen – the achievement which made him the father of modern chemistry – but for his invention we think of less in life-saving than in party-promoting terms – soda water! Almost immediately, his method of impregnating water with 'fixed air' (carbon dioxide) won official recognition because it was thought to have medical potential. Two warships were fitted out by the Admiralty with Priestley's apparatus for making 'aerated water', in the belief that it might prevent scurvy among sailors.

Perhaps Priestley was more prescient than he is credited, because he is said to have coined the phrase 'the greatest happiness of the greatest number', usually associated with Jeremy Bentham.

If happiness can be equated to apparel, then the greatest number were guaranteed exultation when an obscure young man, with nothing to his credit but a £100 loan from a relative, started business in 1900 as a retail tailor. Thirty years later he controlled the largest clothing factory in Europe, the largest chain of tailoring and textile stores in the world, employed 10,000 people and had converted his loan into a £4,000,000 business. His name was Montague Burton, and his Hudson Road Mills in Leeds claimed to be the world's biggest tailoring workshops. The complex covered over 100 acres, and when HRH The Princess Royal came on the 9th October 1934 to open a new canteen capable of accommodating 8,000 at one sitting, Montague Burtons was larger than all the multiple bespoke tailoring businesses in Great Britain combined. Keeping his workforce contented, Montague provided an impressive array of facilities, which included a doctor for free consultations, fully-qualified nurse, qualified dentist, chiropodist,

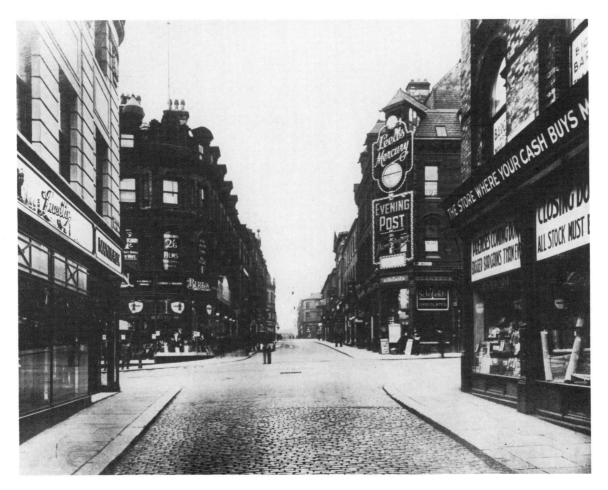

Looking up Upper Head Row from Briggate in 1929 with Burton's
store prominent at the junction.

optician, sick benefit club, sun-ray equipment and sports clubs with their own grounds. Virtually every town in the country was served by a Montague Burton tailors, and at their silver jubilee Lord Calverley was moved to write:

'If good clothes develop a man's self-respect then Montague Burton has played his part in adding to the dignity as well as the adornment of man.'

Sir Montague Burton told the National Institute of Industrial Philosophy that 'A man's general bearing becomes more confident when he is well-dressed', and so 'Mercurious' in the *Leeds Mercury* of the 5th

August 1933 was spurred to poetic comment with the observation:

'The other day I met a man
Whose suit was tailored on a plan
That spoke, as British fabrics can
Of pride, and taste, and cleanness.
His smart and wisely-chosen wear
Reflected quite a business flair,
And gave him just the proper air
Of thoroughness and keenness.

The secret of his fair repute,
If people probed it to the root,
Consisted largely of his suit,
Which fitted him precisely;
For, in his courtship days, he found
His taste in clothes was nobly crowned
When she said "Yes, dear" on the ground
He pressed his suit so nicely!'

Not all the early industrialists were model employers, and it was left to a Leeds man to make his name as a social reformer. He was Richard Oastler, born in Park Square on the 20th December 1789, youngest of eight sons of Robert Oastler, a Leeds merchant. The Oastlers were Wesleyans, and in 1790 John Wesley stayed with them, during which time he took the eight month old Richard in his arms and blessed him. Richard grew up to be a blessing to thousands of children, for he helped to relieve their toil in factories and earned himself the affectionate title of 'Factory King', originally coined in abuse by the *Leeds Mercury*.

Richard had a good education and wanted to enter the legal profession; however his father objected and apprenticed him to an architect. An eye defect caused Richard to leave and become a Leeds cloth dealer instead. On the death of his father in 1820, he took on the management of an estate near Huddersfield, and it

Richard Oastler, known as the 'Factory King'.

was a decade later that occurred a momentous meeting with John Wood, a wealthy Bradford worsted spinner. After-dinner conversation revolved around the cruelties endured by children in the mills, and when the two men parted, Oastler made a pledge to work against the factory system. He penned his famous 'Yorkshire Slavery' letter, which was published, after some misgivings by editor Edward Baines, in the *Leeds Mercury* on 16th October 1830. It fell like a bombshell on the industrialists of the county. Instead of the immediate reform which the ingenuous Oastler had expected, it produced a hardening of opinion. Citing the interdependence of adult and child labour and fear of bad times, the employers came out firmly for retention of the system. Undaunted, Oastler wrote further letters to the *Mercury*. Baines was caught on the horns of a dilemma between his allegiance to influential friends in the business community and his responsibilities to readers, ultimately settling for becoming Oastler's enemy.

Oastler's principal objective was the achievement of a ten hour day. He found there was no shortage of campaign funds from the workers, or allies amongst doctors writing to *The Times* and *Leeds Intelligencer* about the ill-effects on health of the factory system. Lord Shaftsbury represented the burgeoning movement in Parliament. Nevertheless, there was a succession of measures which defeated any progress in Parliament, and in 1832, in a show of strength, there was a great organised march to York of 12,000 footsore and rain-drenched West Riding men who converged on Castle Yard; another great rally was held at Wibsey Moor, when Oastler told the assembly 'It is blood against gold'; and when members of a royal commission visited Leeds, some 3,000 ragged children assembled and chorused the *Song of the Factory Children*.

The movement was temporarily halted in 1833 when a bill largely concerned with children was passed, but this proved unworkable and so the Ten Hours Movement was revived. By now Oastler was both savage and bitter, even advocating sabotage and opposition to the enforcement of the new Poor Law. His state of mind is perhaps best illustrated by the title of one of his pamphlets: *Damnation, eternal damnation to the fiend-begotten, coarser-food New Poor Law*. Perhaps due to his campaigning efforts, he had not devoted as much time as he should to estate management; but whatever the reason there appeared to be some financial discrepancies, and as a result Oastler spent three years and two months in prison. He continued his crusade with *The Fleet Papers*, in which he wrote about the relationship of rich and poor in the new industrial society, advocating better wages for the workers, and decorations and honours for all classes. He urged peasant proprietorship and state aid for the reclamation of waste lands, abolition of indirect taxation, gymnastic training for men and boys, whilst women would receive domestic and hygiene guidance.

At long last, in 1847, seventeen years after his fateful meeting with John Wood, the Ten Hours Bill was passed and the fiery reformer retired from public life, bringing to an end his hectoring rhetoric.

Silently staring out across Water lane near Foundry Street, in that part of industrialised Holbeck which appears to have been bypassed by man, motorway and Mammon, is a large tablet erected by public subscription in 1929. On it is a portrait and a locomotive illustration, together with the lengthy inscription which tells its own story:

'Matthew Murray. Born 1765. Died 1826. Millwright, inventor, pioneer, mechanical engineer. Matthew Murray commenced work with John Marshall of Leeds in 1787 and his many improvements in flax spinning machinery revolutionised the trade. In 1795 he entered into partnership with David Wood and later they were joined by James Fenton and William Lister. Their works, the "Round Foundry",

Engineering genius Matthew Murray.

A view of the works of Fenton, Murray & Wood in Holbeck in 1806. The round building on the left is the fitting-up shop which gave the name 'Round Foundry' to the premises.

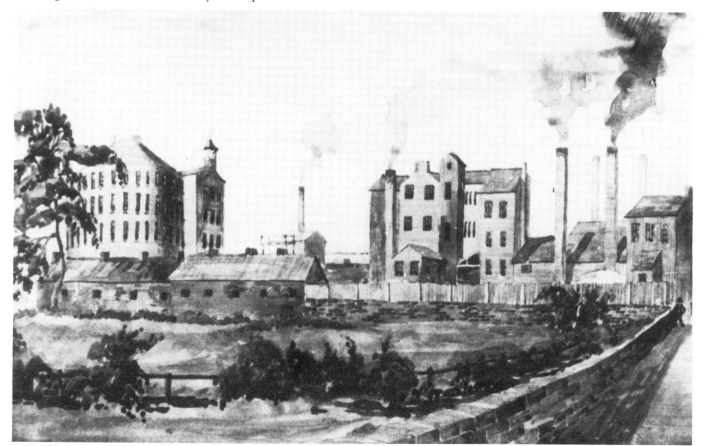

became famous for a high standard of craftsmanship. He was responsible for many important improvements in steam engines including the three-port slide valve. He was a pioneer in the making of machine tools and first introduced the screw feed boring machine. He made the first hydraulic testing machine for loads up to a thousand tons and invented a gauge for measuring such pressures. The wide range of his mechanical achievements justifies the title Father of Leeds Engineering. Steam locomotives of his design ran on the Blenkinsop rack railway between Leeds and Middleton from 1812 to 1835. The locomotive had two cylinders with cranks at right angles and they were the first to be commercially successful on any railway. He also, in his own house in Leeds, created the first centrally heated building in the world, colloquially known as "Steam Hall".'

Thus was transformed the penniless mechanic from Stockton who had walked into Leeds in the 1790s and begged a night's lodgings.

In his wake came numerous other metal and engineering concerns, eager to offer locomotives for any gauge, traction engines for threshing, steam-plough machinery 'for all lands, crops, and climates', as well as steam, hydraulic and electrical pumping machinery, and loading and unloading machinery 'for handling all materials'. In the light of this enterprise, it is difficult not to agree with the *Yorkshire Post* comment of the 28th March 1908 that '. . . considering its eminence as an engineering centre the part played by Leeds in the manufacture of motor cars has been curiously insignificant'. Clearly an appeal for a budding Henry Ford!

Perhaps if one had emerged, he would have faced considerable opposition from such men as William Paul in Kirkstall Road, who was a leading tanner and supplier to the extensive footwear industry in the town. In 1870, Leeds ranked first in the kingdom for leather output. By 1893 some 11,500 people were

This advertisement from the turn of the century is a reminder that strong footwear was an important requisite of the thousands of workmen who toiled in the factories.

engaged in the industry, which supported 34 tanneries, 60 curriers, 700 'shoemakers' and 100 other footwear manufacturers. Machinery played a vital role, and much of it was the invention of Paul himself. As might perhaps be expected in the industrial heartland, demand for workboots was heavy and some 100,000 pairs a week were being produced by the turn of the century; in addition to which there was a widespread need for special harness leathers before the advent of the automobile. Increasing leisure meant more time to indulge in pastimes like soccer, which brought to Leeds 'the football-hide trade'. (This was so extensive that football manufacturers were ordering hides in batches of 500 at a time.) The First World War produced an unexpected demand for army boots, but social changes marked the demise of a once-thriving industry.

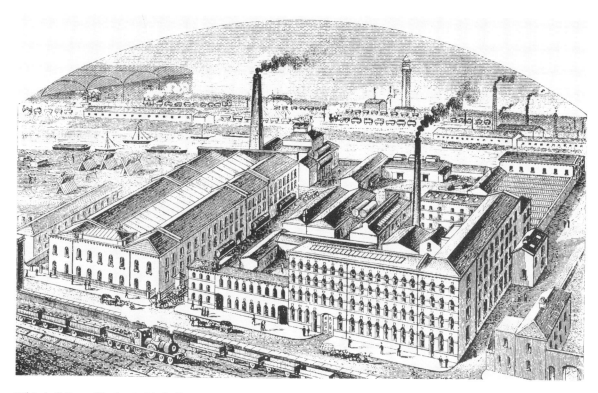

Whitehall Soap Works, Whitehall Road, about 1893.

A visitor to the Paul Tannery observed that ' . . . the odours call up no sweet fancies about spices of Araby' – in marked contrast to the works of Joseph Watson and Sons in Whitehall Road, described as 'one of the sweetest, most delicately perfumed factories in Yorkshire'. From an 1830s trade in hide and leather dressing (as well as being the largest buyer of skins in the North), the business was changed into soap manufacture in 1848. By 1893 it was employing 700 people to turn out 600 tons of soap a week; and by 1906 some 24,000 tons of soap a year were being produced here. Small wonder, then, that 'Soapy Joe's', making such famous products as Watson's Matchless

Jimmy Wiggles was a familiar character used to advertise Matchless Cleanser made at the Whitehall Soap Works.

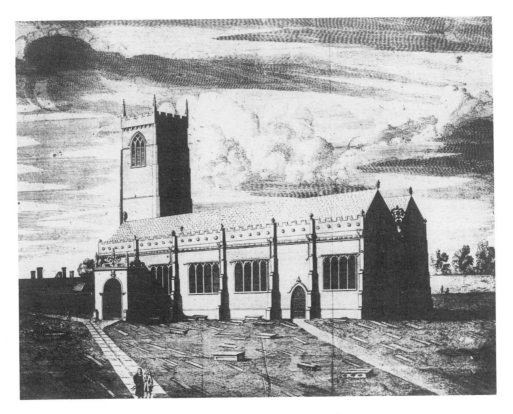

St Johns Church from an engraving of 1908.

Cleanser and Venus Soap, became the biggest rival of Lever Brothers, who acquired the business in 1918.

During the Second World War, the factory undertook the unlikely task of manufacturing munitions and soap in the same building. Conveniently, one of the major byproducts of soap at that time was glycerine, which was used in the manufacture of explosives too. By the early 1960s, Whitehall Road had the largest toiletry manufacturing plant in Europe, with more than 800 people employed in making any of 264 different products from shaving soap to toothpaste.

Although the sweet smell of individual success may be easy to identify, it is often more difficult to distinguish between the eminent and the eccentric. This is especially so when looking at the life of John Harrison, who was probably the greatest benefactor of the city. For nearly forty years he was a clothier in Briggate, and amassed a considerable fortune – much of which he spent in numerous charitable works.

One such was St John the Evangelist Church in Briggate, for which Harrison 'accepted of no assistance in the building of that fair fabric but what he fully paid for, so that he may be owned the sole

founder thereof'. Building was begun in 1631, and it was consecrated on the 21st September 1634. The first minister was Robert Todd, who was suspended on the very day he started his duties. The consecration ceremony was performed by Archbishop Neale, who appointed his own chaplain, Dr Coren, afterwards Bishop of Durham, to preach the sermon. Mr Todd preached in the afternoon and – by some unguarded remark which was thought to reflect on the sermon preached by Dr Coren in the morning – gave so much offence that he was suspended for a year.

When Harrison died he was buried in his own orchard in Kirkgate, but afterwards removed to St Johns Church where a black marble monument was erected in his memory with the specially-composed eulogy:

'Here resteth the body of Mr John Harrison, the wonder of his own, and pattern of succeeding ages. Eminent for prudence, piety, loyalty, charity, who (besides other works of a pious munificence and many great instances of an excellent virtue) founded a hospital for the relief of indigent persons of good conversation, and formerly industrous. Built the free school of this town, for the encouragement of learning, together with a chappell; this church (which most may envie) for the exercise of religion, and endowed it with eighty pounds per annum. Also that he might do good in all his capacities, he erected a stately cross for convenience of the market, and having given these pledges of a joyful resurrection fell asleep Oct 29th *Anno Dom 1656 Aetatis Suae 77.*'

After such a tribute, it might be considered frivolous to suggest that the old gent was also a bit eccentric, but records suggest that it might not be untrue. In Briggate, opposite the east end of Boar Lane, he built himself a house with a quadrangle court in the middle and 'singular peculiarities in its construction'. These are accounted for by what was described as his 'ludicrously extravagant attachment to cats'. In

consequence, the house had a large number of holes and passages cut in the doors and the ceiling to allow their free entrance and exit. After his death it was converted into shops, and later became well known as the Kings Arms Tavern, before serving as offices for the *Leeds Mercury* and subsequently being demolished.

And what are we to make of Robert Arthington, whose Quaker father closed down his brewery because conscience prohibited him from selling intoxicating drink? He could afford his scruples, as he had already amassed a fortune which he left to Robert. Whether in further penitence, self-reproach or parsimony, this millionaire lived alone in his great house at Headingley without a fire in the coldest winter. His sustenance was a loaf of bread and a jug of milk left on his doorstep each day, for he saw few people. On a rare occasion when he did venture out, one of his few friends chided him for wearing a shabby coat with the words: 'Your father would never have been seen in a coat like that'. Robert Arthington responded: 'Oh, yes, he would; it was his coat!'

This idiosyncratic character had one enthusiasm – foreign missions. When he died aged seventy-seven in 1900, he left his fortune of about £1,000,000 to the London Missionary Society and the Baptist Missionary Society, who spent it establishing a chain of missionary outposts across Africa in memory of this son of the city.

Time To Spend

One of the thrills of my life as a young child was to be taken into Thornton's Arcade just on the hour to join the inevitable crowd of shoppers watching the animated clock with its scene from Sir Walter Scott's *Ivanhoe* – Richard Coer de Lion and Friar Tuck, Robin Hood and Gurth the swineherd, striking out the hours and the quarters with their fists, or so it seemed to mesmerised watchers like me. The clock, made by Potts, is five feet six inches high and two feet wide, and the massive cast-iron frame is made in such a way that any wheel can be taken out separately without disturbing the other parts.

Variously described in nineteenth century trade directories as a maltster, licensed victualler and brewer, Charles Thornton was in the 1890s the proprietor of the Varieties Music Hall. He epitomised the increasingly prosperous middle class of the era and, like most Victorians, he was deeply influenced by the works of John Ruskin and Alfred Lord Tennyson.

Adjacent to the music hall, he owned property which had once housed cockfights to entertain the less affluent, but in the spirit of the times he decided to erect a magnificent Italianate arcade. Then – as now – planning permission was not easy to come by, and Thornton ran into difficulties with the corporation. They refused to let him build the arcade without a drain underneath it – a feature that he felt it was the corporation's duty to install. The project was shelved for some time, and when building eventually began the design had changed from rounded Italian arches to pointed Gothic ones. The result was a vaulted arcade with a medieval cathedral-like air, which doubtless appealed simultaneously to Thornton's showmanship and artistic aspirations.

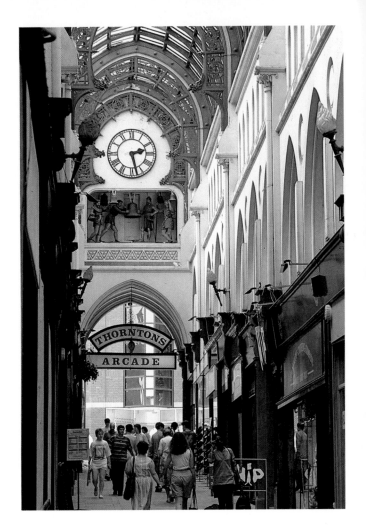

Thornton's Arcade.

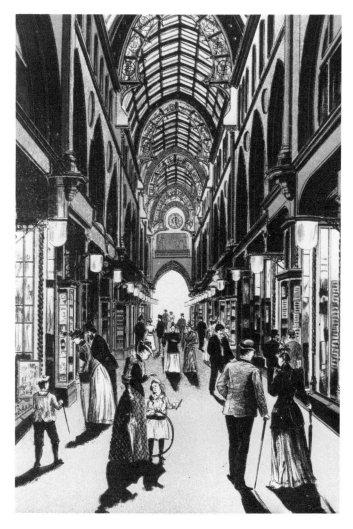

An artist's impression of Thornton's Arcade shortly after it was opened.

But Thornton was no burlesque character, and was well-respected. A contemporary described him as 'a tall majestic figure with a long white beard', and he took a close personal interest in the tenants of his arcade, especially those who were with him from its opening in 1877. Thornton might well have been tempted to build more arcades, but he died in 1881 aged fifty-nine.

His arcade must have been a godsend to shoppers, who could stroll around the shops in all weathers, protected from the rain and mud as well as the noise and stench of the horse-drawn traffic of those days.

Like any other good idea it had its imitators and there were businessmen eager to copy, so in due course more arcades were built. Each was more grandiose in style than the one before. The results were destined to make Leeds one of the most compact and comfortable shopping centres in the North. In comparison the average pedestrian shopping centre created a century later, although pioneered in Leeds, still looks comparatively soulless.

When in 1889 Queen's Arcade off Briggate was completed, the *Yorkshire Post* was inspired to comment:

'The edifice is light, bright, and architecturally elegant and is moreover, admirably designed from the business point of view.'

Grandiose in conception and in name was the Grand Arcade, completed in 1898 – close to the Grand Theatre in Briggate. More ambitious than its predecessors, this was built as a double arcade with two parallel banks of shops forming six blocks. In the 1920s about a quarter of the arcade was used for the Tower Cinema, but its undoubted major attraction was – once again – a Potts clock. Unfortunately it has been moved and had several facelifts which have done nothing to enhance its original character, but its animated figures still come out every hour like elderly, creaking ghosts from the past. On the hour the doors

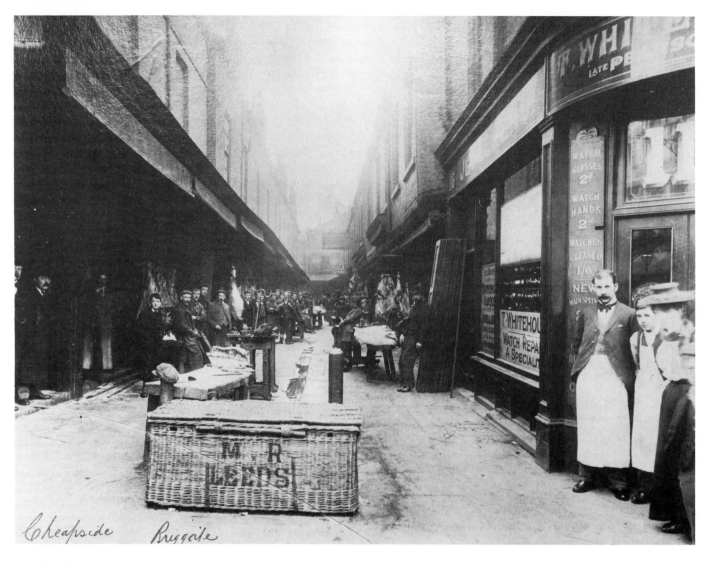

Cheapside Briggate

Food hygiene and customer appeal were unknown by traders and shoppers alike, as is evidenced by this old photograph of Cheapside off Briggate.

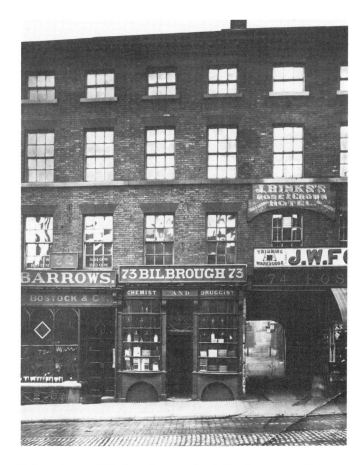

Taken about 1888, this photograph of Numbers 72–74 Briggate shows the entrance to Rose and Crown Yard.

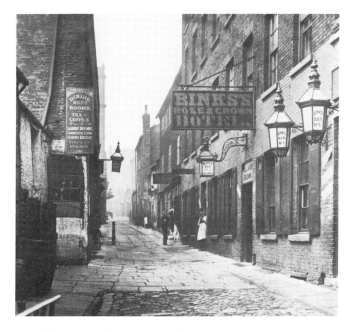

Squalid property like Rose and Crown Yard, seen here in 1887, gave way to become Queen's Arcade.

of Windsor Castle open and two knights with battle-axes come out to strike the time. They are followed on a revolving stage by a guardsman giving watchers a jerky salute, a Scotsman in a colourful kilt giving a stiff bow, an Irishman with a shillelagh, a Canadian in fur hat and thigh boots carrying a paddle, and finally an Indian in a loincloth bowing with his hand to his stomach. When they have disappeared back into their lair, a cockerel above the dial flaps its wings and crows. Legend has it that on one occasion the arm of one of the knights fell off into the arcade. The sensitive workman sent to remove the statue for repair carried it through the streets wrapped in a white cloth. As the Abyssinian War had just broken out, he was jokingly reported to be carrying the first casualty!

Originally the clock was situated in an offshoot of the arcade, but on the 8th July 1939, after the Grand Arcade had been sold, the new owner decided to renovate and move the timepiece to a more favourable position at the Vicar Lane end, which was accomplished by the 7th November 1939. The inscription underneath formerly read 'Come what may, time and the hour runs through the roughest day' from *Macbeth*. In 1967 this was altered to 'Time and tide wait for no man'.

The Grand Arcade clock.

The Headrow, and Lewis's store in the distance.

Queen Victoria's diamond jubilee was commemorted with the creation of Victoria Arcade, and then came the last of the Victorian arcades – County – which was opened in 1898 as part of a major redevelopment of the area between Briggate and Vicar Lane, carried out between 1898 and 1903.

County Arcade was intended to warrant all the superlatives – most magnificent, widest, longest, most flamboyantly Romanesque. Beneath its domes are fine gold-capitalled columns of Sienna marble, supporting allegorical mosaics in red, green and gold. Depicting liberty, commerce, labour and art, the themes of the mosaics are perhaps more English esoteric than exuberant Italian, but they are an abiding monument to that mixture of commercial shrewdness, love of classical and romantic beauty, and pious religiosity that was uniquely Victorian.

The arcade was built on the site of White Horse Yard. The narrow thoroughfare of Wood Street then became Queen Victoria Street, and Cheapside became King Edward Street. Although entered only by a

passage from Briggate, Wood Street was occupied by many prosperous Briggate traders. Two of its best-known establishments were Broadbent's Oyster Shop and Parker's Coffee House, a temperance meeting-place where high-class debates were held on Sunday evenings; many local politicians first cut their debating teeth there.

Queen Victoria Street and King Edward Street were named after the monarchs, and the complex was built to an overall plan, with a uniform red and orange facade lavishly decorated with gables, corner towers and architectural trimmings.

The whole redevelopment scheme was designed by famous London architect Frank Matcham, who designed more than a hundred theatres and music halls throughout the country. Not surprisingly, then, the Leeds scheme included the Empire Music Hall.

Also included was the King Edward Restaurant, furnished with a Mexican onyx marble staircase, mosaic floors, and polished marble walls and columns, creating what was described as 'The Handsomest Grill

The Bond Street Centre off Boar Lane.

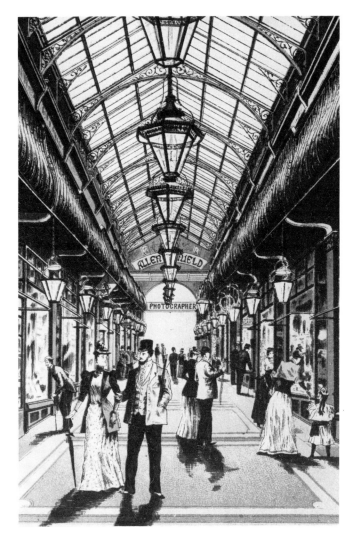

The emergent middle-class leisurely promenading and shopping in the new Queen's Arcade, as seen through the eyes of a contemporary artist.

Room in the United Kingdom'; and a hugely popular venue for professional people, businessmen, visiting theatrical performers and romantic liaisons.

Another meeting place for many courting couples was under Dyson's clock in Briggate, one of the most famous landmarks in the city. As the name on the facade proclaims, it is Time Ball Buildings, where in 1865 John Dyson founded his clock and watch-repairing business. The property dates back to 1650, but was extensively strengthened, rebuilt and refurbished at a cost of £250,000 for its reopening on the 19th May 1980.

Cantilevered over the pavement, surmounted by a golden Father Time with the motto *Tempus Fugit* underneath, is the giant clock whose works were displayed on the main counter inside so customers could appreciate the craftsmanship involved.

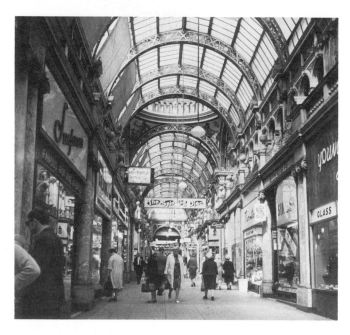

Protected from inclement weather by the elegant roof, shoppers can unhurriedly peruse the goods displayed in the windows of traders in County Arcade.

It is two clocks really, for there is an even bigger one set into the Briggate frontage. This was set going in 1910 to mark the birthday of John Dyson's wife, and its great pendulum descends through the floor to swing in a well in the basement (it has the same movement as Big Ben). Inside, the shop has two great chandeliers hanging from ornate ceilings like giant glistening waterfalls of light. These were brought to Leeds from the Paris Exhibition of 1890, and John Dyson powered them by electricity made by a gas engine in the cellar, so becoming one of the first shops in the city to be lit in this way. The whole interior was like an emporium, with glass counters set in ebonised mahogany, red carpets, ceilings gilded with gold leaf, stained glass windows, acid-embossed glass, statuettes, huge busts and other antiques collected by the Dyson family, as well as clocks like balloons, lighthouses, waterfalls and other extravaganzas. Sadly the shop closed early in 1990, but the building has been preserved.

Time to browse has been the incentive for many people to part with their money at Austicks, whose name in the city has become synonymous with books and other publications. But it has not always been so. On the Saturday in February 1928 when Bertie Lister Austick opened for business as a new and second-hand bookseller in Park Cross Street, his takings were just one shilling and threepence – and that was a sale to a close relative. Nor did takings increase rapidly, for the average turnover in the following weeks was only £19 19s. Nevertheless his persistence paid off and he acquired another shop in the same street, and on the 31st October 1930 moved into the well-known premises in Cookridge Street. Under the motto 'You want a book – We want to get it for you – Let's', the bookselling service prospered, despite some setbacks.

Bertie's sons David and Paul joined the family business, and began in 1950 a considerable programme of expansion, acquiring new property and extending the Cookridge Street shop to cope with the increasing demand for academic textbooks for the growing number of college and university students. More premises were obtained, both within colleges and outside, as Austicks acquired businesses in Leeds and Scarborough where they traded under a variety of names. Thousands of schoolchildren were introduced to the pleasures of reading and owning their books through Austicks Puffin School Book Club launched in 1974, and in 1984 the specialist Barkers Music Shop in the Headrow was taken over, to be joined three years later by Music Makers of Harrogate.

To celebrate the diamond jubilee year of the multi-

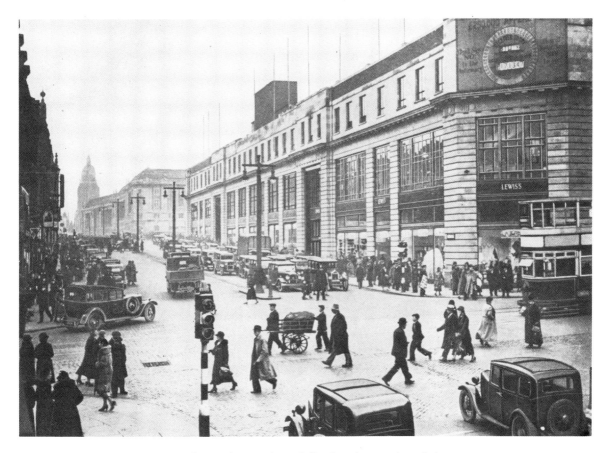

A busy day in the Headrow following the opening of the new
Lewis's department store.

branch organisation that had blossomed out of a 12 foot by 10 foot shop, Austicks opened their Map and Travel Bookshop in the Headrow – doubled in capacity two years later. And many bibliophiles shed a nostalgic tear when the Cookridge Street shop was vacated in 1990 to make way for redevelopment, but the new branch in the Merrion Shopping Centre promises to absorb the presence and time of ever more customers.

Mecca for many enthusiastic shoppers is Lewis's department store on the Headrow. The six-storey edifice cost £750,000 and a further £160,000 for the site. On the first day it opened its door to the public – Saturday the 17th September 1932 – 120,000 visitors thronged its departments, in which the only articles 'from a theatre ticket to a permanent wave, a pound of sausages to a suite of furniture' that could not be obtained after four o'clock were lobsters. They had

Red Hall, built in 1628 by Thomas Metcalfe, was so called because
it was the first house in Leeds to be built of brick. It was bought by
Schofields in 1911 and demolished in 1961.

been selling all day at ninepence each and had sold out!

Even older and standing on one of the most historic and colourful bits of Leeds – the old Red Hall, Cock and Bottle Inn and the Hippodrome – was Schofields, on the opposite side of the Headrow. Schofields, unlike Lewis's, grew from modest beginnings on the site. Snowden Schofield opened a fancy drapers and milliners shop at 1 Victoria Arcade with three assistants on Saturday the 4th May 1901. His takings for that day as shown in the first cashbook were £62 3s 4d, of which £43 10s was in gold. He recorded that it was beautiful weather and the shop was packed all day. He prospered, buying up adjacent and nearby shops.

An advertisement designed to attract the aspiring lady to languish at Schofields, where she was entertained by a ladies' orchestra.

Inspired by his success, the prospering young businessman devised new means of capturing the attention of prospective customers beyond the city boundaries. He advertised by letters, posters, bills and catalogues; and finally abandoning his other forms, except the catalogues, he concentrated on a hitherto neglected medium, the press. In this he was a pioneer in Yorkshire, if not the provinces generally. At the beginning of the twentieth century, when only such things as quack medicines were offered to the public through the press, he was the first man in Leeds to buy space on the front page of a newspaper for display advertising, and recorded that he had to overcome a certain amount of diffidence on the part of the proprietors before being allowed to do so!

His move proved eminently successful. Looking back on this revolutionary step, he once said:

'We first advertised what to us was a huge quantity of nappa gloves. There were several hundred pairs, and we bought them for one shilling a pair and sold them at one shilling and three farthings. We told the public about them in an advertisement four inches deep across two columns. We sold every pair in three days. Nevertheless it required courage and faith to continue, because the public were not used to seeing drapery advertised in that manner and probably thought it was not absolutely genuine. We succeeded by keeping our promises to the public and never exaggerating the good points of what we had to offer . . . and soon came to realise that the newspaper was our biggest shop window.'

In 1911, after other expansion, he acquired the first brick-built house in the city – Red Hall, with its quaintly-structured gabled roof built in 1628 by Thomas Metcalfe, alderman and merchant. (King Charles I was sheltered here as a prisoner in 1647 before being taken to London for beheading in 1649.) In 1934, Snowden Schofield purchased the Hippodrome, which had been closed as a theatre in 1933, ending a tradition stretching back almost a century; Vesta Tilley played here for £35 a week, Dan Leno for £40 a week and Jennie Hill was paid £84 to perform on two nights in 1890. In 1938, Schofield bought the Cock and Bottle Inn which faced the Headrow and had divided his store for some years. (The inn was a striking example of eighteenth century architecture and had been the starting place of the *Eclipse* coaches which ran to Ilkley.) The Black Bull and Sun Inn had both been displaced by the construction of the Victoria Arcade, and in 1947 the whole arcade was acquired by Schofields for £250,000.

So when Snowden Schofield died on the 24th March 1949, he had become owner of the entire site in which forty-eight years earlier he had rented a single shop at

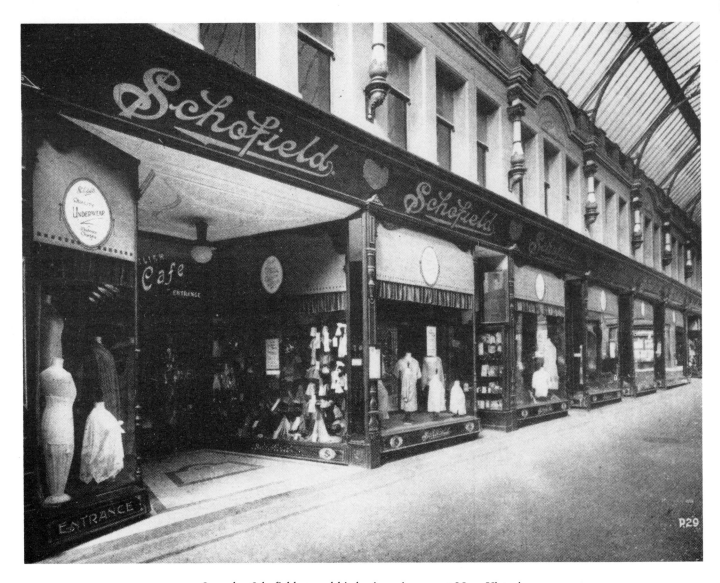

Snowden Schofield started his business in 1901 at No 1 Victoria
Arcade, and progressively acquired all of it.

£50 a year. In 1984, Schofields was sold to a London property developer, who in 1987 also acquired a former Woolworths store in Briggate in which Schofields continued trading whilst their original site was developed. By October 1989 the £16,000,000 Schofields Centre shopping complex was sufficiently completed to accommodate Marks and Spencers as well as forty other shops and cafes, with the final accolade being the return of Schofields in August 1990.

Undoubtedly the classic effort to supply the extensive working-class population was the co-operative movement, which was extremely strong in Leeds. So much so that by the end of the nineteenth century the Leeds Co-operative Society had grown into a highly-integrated concern of considerable size. It prompted a writer in the *Yorkshire Factory Times* of the 25th December 1896 to claim it was 'the largest on Earth'. He pointed out that it boasted more than 33,000 members and a turnover in the five years up to the 30th June 1896 of £4,305,170, '. . . a sum too vast to comprehend by ordinary mortals [sic] who only see copper and silver'.

Precursors of modern supermarkets, over seventy of their stores traded in the Leeds area, retailing a wide range of goods, many of which came from the society's own farm or from its boot and shoe, flour, clothing and brush works.

Jewel in the crown was the huge store in Albion Street, opened in 1884 and extended ten years later. It is still there, although twentieth century developers have turned Albion Street into a space age shoppers' paradise; a cavern filled with a myriad of glittering stores and moving pavements that sweep shoppers off their feet into an artificial world devoid of daylight, almost with its own atmosphere. Dropping down from it into Boar Lane is a long tube of brown plastic beckoning passers-by with its gaping orifice. It sucks up the punters and blows them in and out of the modern shopping mall with the ease of a vacuum cleaner.

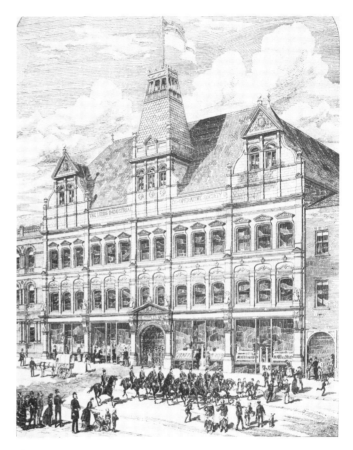

The Co-operative Stores in Albion Street from *The Architect*, June 1884.

Imagine if you will the wide-eyed astonishment of the cloth traders of yesteryear, were they able to return and compare it with the nationally famous market which once sprawled all the way down Briggate to Leeds Bridge. The scale of this activity was graphically described in Daniel Defoe's *Tour through the Whole Island of Great Britain* in 1724. He tells us:

'The clothiers come early in the morning with their cloth; and as few clothiers bring more than one piece, the market being so frequent, they go into the inns and publick-houses with it, and there set it down.

At seven o'clock in the morning . . . the market bell rings; it would surprise a stranger to see how in a few minutes, without hurry or noise, and not the least disorder, the whole market is fill'd; all the boards upon the tressels are covered with cloth, close to one another as the pieces can lie long ways by one another. And behind every piece of cloth, the clothier standing to sell it.

As soon as the bell has done ringing, the merchants and factors, and buyers of all sorts, come down and coming along the spaces between the rows of boards, they walk up the rows, and down as their occasions direct. Some of them have their foreign letters of orders, with patterns seal'd on them, in rows, in their hands; and with those they match colours, holding them to the cloths to their colours, or that suit their occasions, they reach over to their clothier and whisper, and in the fewest words imaginable the price is stated; one asks, the other bids; and 'tis agree, or not agree, in a moment.

The merchants and buyers generally walk down and up twice on each side of the rows, and in little more than an hour you will perceive the cloths begin to move off, the clothier taking it up upon his shoulder to carry it to the merchant's house; and by half an hour after eight o'clock the market bell rings again; immediately the buyers disappear, the cloth is all sold, or if here and there a piece happens not to be bought, 'tis carried back into the inn, and, in a quarter of an hour, there is not a piece of cloth to be seen in the market.

Thus, you see, ten or twenty thousand pounds value in cloth, and sometimes much more, bought and sold in little more than an hour, and the laws of the market the most strictly observed as ever I saw done in any market in England; for,

1) Before the market bell rings, no man shows a piece of cloth, nor can the clothiers sell any but in the open market.

2) After the bell rings again, nobody stays a moment in the market, but carries his cloth back if it is not sold.

3) And that which is most admirable is, 'tis all managed with the most profound silence, and you cannot hear a word spoken in the whole market, I mean, by the person buying and selling; 'tis all done in a whisper.

By nine o'clock the boards are taken down, the tressels are removed, and the streets cleared, so that you see no market or goods any more than if there had been nothing to do; and this is done twice a week. By this quick return the clothiers are constantly supplied with money, their workmen are duly paid and a prodigious sum circulated thro' the country every week.'

But inclement weather does not operate to schedule, and traders as well as customers preferred to be indoors. Anxious glances were cast south, for Wakefield had built a new cloth hall which seriously threatened the supremacy of the Leeds market. Not to be outdone, the Leeds merchants and traders responded in 1711 with a 'stately hall for white cloths' in Kirkgate. Surmounted by a gilded cupola, this 297 feet long and 210 feet wide two storey hall, built around a quadrangle with pillars and arches, was replaced in 1775 by a new one in Cloth Hall Street, providing 1,213 stands on which West Riding clothiers could exhibit their products. A Coloured Cloth Hall

The old Kirkgate market before 1904.

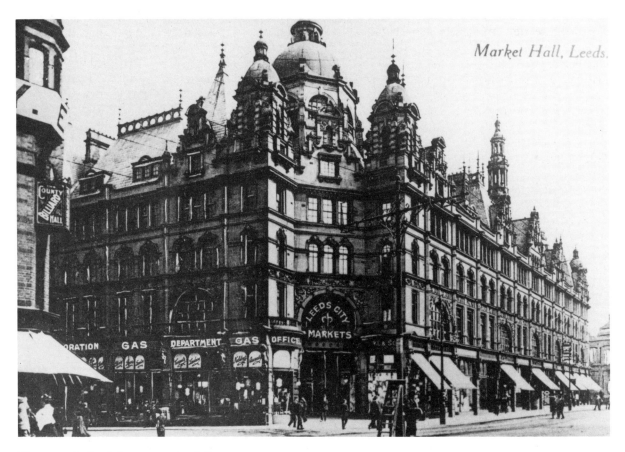

Market Hall, Leeds.

The ornate bulk of the new market hall.

had been built in 1758 in Infirmary Street, and together these served a prodigious trade. Within the space of a century, production of pieces of broad cloth in the West Riding increased from 30,000 to 300,000 pieces a year, whilst narrow cloths more than doubled from 60,000 to 130,000 pieces a year. Leeds was the natural gateway through which most of it passed.

Burgeoning commerce meant an expanding population, whose need for comestibles resulted in the creation in 1857 of a market hall built in the Crystal Palace style on a site known as Vicars Croft. This was replaced in 1904 after reconstruction costing £80,000, for which architects Leeming and Leeming produced for the twelve acre site a facade heavy with sculptured lions. A disastrous fire destroyed two-thirds of the interior in December 1975, but, phoenix-like, another market has risen from the ashes. The £1,600,000 rebuilding was completed on the 27th November 1981 and although now only three and a half acres it is believed to still be the largest covered market in England.

A feature of the new market is an elegant clock mounted on an antique fluted cast-iron pillar under the central dome. Presented by Marks and Spencer, it stands just 200 yards from the spot where Michael Marks first ran his stall. And whilst the name of the company is synonymous worldwide with value and quality, few people are familiar with the true story of its origins.

In 1884, a twenty-one year old wealthy Leeds wholesaler called Isaac Dewhirst was walking in the vicinity of Kirkgate with one of his employees, Charlie Backhouse, when they were approached by an inarticulate immigrant. He knew only one word of English – 'Barran', the name of the textile firm which employed immigrant labour and for which, apparently, he hoped to work. Backhouse, fortunately, could speak a little Yiddish and a three-way conversation ensued. Impressed by the immigrant's commercial sense, Isaac Dewhirst granted him £5 worth of credit at his warehouse in Leeds. This credit enabled the young Lithuanian Jew to set up his celebrated 'Penny Bazaar' in the market. The famous sign on the stall, 'Don't ask the price, it's a penny', may have been put up in order to spare the young immigrant the pain of haggling in a foreign tongue, but his commercial sense may have had something to do with it too.

His untutored mind had no doubt grasped that it was just as easy to induce 3,000 people to part with a penny apiece as it was to extract 1,000 pennies from a rich man's purse. Being something of a pioneer, he deserved to make a fortune coming from poverty-stricken Eastern Europe. And he did. His name, of course, was Michael Marks. But for that accident of fate, he might have found his way to 'Barran' and disappeared into the web of late nineteenth century textile manufacturing industry.

In 1891 he moved his expanding business over to Wigan – which had a large market – and by 1894 had decided he needed a partner. So it was that Tom Spencer from Skipton joined Marks, and the combined firm moved to Manchester in 1897, followed in 1921 by the establishment of the headquarters in London. Simon Marks took over the business in 1909, recognised the possibilities for quality goods, and built up the chain of Marks and Spencer stores which have had such a profound effect all over the country.

The rest is history – or legend at least.

Michael Marks (left) and his partner Tom Spencer, whose names have become synonymous with quality across the world.

The mind boggles at the time and energy needed to put these implements on display every morning and then take them down again at night, at the shop of A Lewis of 17 Lower Head Row. The photograph was taken in the mid-1920s, when Lewis sold sports and fancy goods, musical instruments, tools and sporting guns.

The last bow-windowed shop in Briggate, about 1900. It was demolished in 1922. The passage on the right is the entrance to the Turks Head, better known as Whitelock's.

By His MAJESTY's Servants.
At the NEW THEATRE, LEEDS,
On Wednesday the 24th of July Instant, will be presented
A COMEDY, call'd
A Word to the Wife.
(With an Occasional PROLOGUE)
To which will be added, a Musical Entertainment,
call'd,
Thomas *and* Sally.
The Characters will be expressed in the Bills of the Day.
To begin exactly at Seven o'Clock.
Boxes 3s.—Pit 2s.—First Gall. 1s. 6d.—Upper Gall. 1s
☞ The Theatre will be elegantly illuminated with
Wax-Candles.
Tickets and Places (for the Boxes) to be taken of Mr.
W. Powell, Box-Keeper at the Theatre.

An advertisement from the *Leeds Intelligencer* of the 30th July
1771 for a production at the Hunslet Theatre.

An evocative Grand Theatre playbill of 1899, doubtless intended
to symbolise the marriage of art and industry.

The largest theatre outside London, the most comprehensive to be built since the National and the last major new drama venue of the twentieth century opened its doors on Thursday the 8th March 1990 with an eighteenth century comic romp. John O'Keefe's *Wild Oats* – appropriately a celebration of the joys of a vagabond actor's life – launched the £13,000,000 West Yorkshire Playhouse, in the larger of its two contrasting auditoria, the 750-seater Quarry. In addition to the thrust-stage Quarry (named after the flats that formerly occupied the site), the new theatre off York Lane also has the complementary flexible Courtyard auditoria which holds 350, offering the opportunity for staging experimental productions. The expectations are that this will be a resounding success, and confirm the city as a venue worthy of the most famous theatrical performers.

However, Leeds unfortunately once enjoyed a reputation for having little appreciation of the thespian art. And its citizens were not slow in demonstrating their rather vicious sense of humour by barracking the artists.

Across Leeds Bridge, in Hunslet Lane near Salem Chapel, was Leeds' first theatre, opened in 1771. Attracting star performers was no easy task, so when the famous Mrs Siddons agreed to appear in September 1786, it was an occasion demanding special advertisements. Patrons were assured that 'The Theatre will be elegantly illuminated with wax candles', and, in anticipation of a heavy demand, 'To prevent confusion servants are desired to be in the theatre by 5 o'clock to keep places'. Then, as now, big star meant big fee. In consequence the usual prices of boxes 3 shillings, pit 2 shillings, and first gallery 1 shilling and sixpence, were increased to 5, 3, and 2

The market clock presented by Marks and Spencer, close to the spot where Michael Marks had his first stall.

An artist's impression of Michael Marks's original stall in Leeds Market.

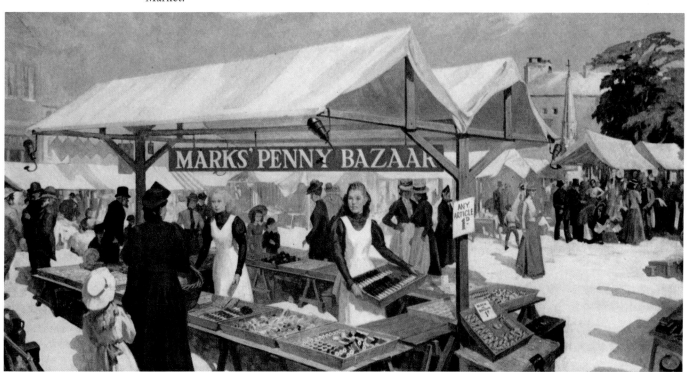

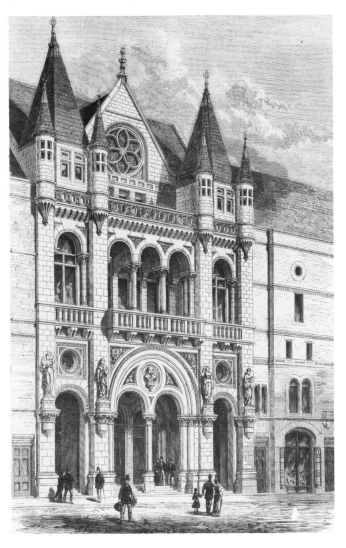

An engraving of the Grand Theatre from 1878.

shillings respectively. Only the upper gallery maintained its usual price of a shilling – unwise with the benefit of hindsight.

The tragic climax of the drama came when Mrs Siddons was to drink poison, at which time the lampooning comments also reached their peak. As Mrs Siddons melodramatically executed the final moments towards a torpid demise, a voice from the gallery trumpeted: 'That's right, Molly lass, sup it up!' That night was etched on Mrs Siddons' soul forever. Come the end of the engagement and her final curtain speech, she departed with: 'Farewell, ye brutes, and forever I trust. Ye shall never torture me again'.

Mrs Siddons may have 'died' in theatrical terms, but on the 20th June 1817 real-life tragedy struck Alexander Cummins, who was appearing at the Hunslet Lane theatre in the play *Jane Shore*. Playing the part of Dumont, poor Cummins had just invoked Heaven when he fell backwards into the arms of another actor and died so gently that it was not apparent to those near him. According to his gravestone in the churchyard of St John the Evangelist, he was 'an established favourite of Yorkshire Theatres for upwards of Forty Years'. Nearby, another headstone commemorates 'John Southgate, comedian, who departed this life June 1976 in the 34th year of his age'.

By the middle of the nineteenth century the Hunslet Lane theatre had become dilapidated. It was demolished and replaced by a new one in 1867 with seating for 2,000, only to be destroyed by fire in 1875. But the emergent gentry of Leeds needed to manifest their cultural advancement, and so the Grand Theatre in Briggate was conceived as 'a noble temple of drama', in which it could be demonstrated that 'the English play . . . has attained a dignity, grandeur, and purity which in our national history has never been surpassed'. Opened on the 18th November 1878 at a cost of £70,000, it was designed by George Corson in

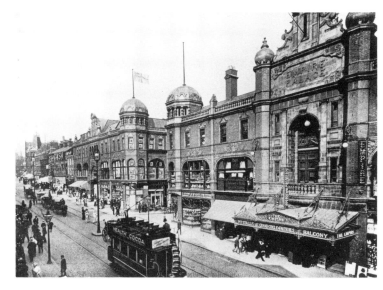

Briggate in 1903 with the Empire Theatre, whose boards were trodden by many great music hall stars. Theatregoers at that time were using hansom cabs or open-top trams.

an Italianate form of Gothic, using clustered piers with Italianate scrolls to decorate the auditorium.

It was lower down Briggate at the Empire Theatre – which provided entertainment for those unencumbered with cultural pretensions – that stage history was made. Here the great escape-artist Harry Houdini met his match. The only thing known to have defeated him proved to be – Tetley ale. Due to appear at the Empire Theatre for the week starting the 6th February 1911, the great illusionist invited challenges from local firms and organisations to devise a means of securing him so that he could not escape. His confidence was justified, since nobody had ever succeeded: prison cells, a solder-sealed metal coffin submerged in water, specially-made police handcuffs, straitjackets, allegedly burglar-proof safes and so on had all been tried . . . and found wanting.

But he had not reckoned with Leeds ingenuity, for he was challenged to escape from a metal cask filled with ale from Joshua Tetley and Son's brewery; a feat he undertook to attempt on Thursday the 9th February 1911. As Milbourne Christopher relates in *Houdini – the Untold Story*:

'In Leeds a local brewer filled his Water Can with Beer. Padlocked inside, Harry, who didn't drink, was overcome by the alcohol. Had it not been for Franz Kukol, he might have been drowned.

He was only partially conscious when Kukol, disturbed by the quiet behind the curtain, dashed into the cabinet and hauled him out of the can.

Afterwards a stagehand joked: "Why run away from the beer, Mr Houdini? It's what most of us run after."

He was in no mood to laugh.'

The new West Yorkshire Playhouse.

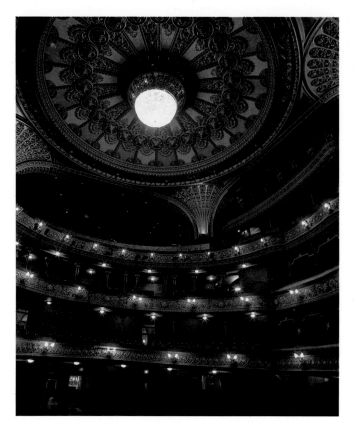

Ornate decoration inside the Grand Theatre.

Seventy years later, on Saturday the 18th June 1983 in front of a crowd of 2,500, escapologist David De Val successfully performed the feat when he emerged from a fifty gallon cask of Tetley bitter. But De Val reckoned with something Houdini had ignored, although the discovery had been made in Leeds a century and a half before Houdini's attempt. That something was the carbon dioxide given off by all beer. As De Val explained:

'Although he, and I, both managed to perform the escape in water, with beer it is a different matter as carbon dioxide builds up in the barrel if there is any air space and can send you unconscious.'

Many of the parched onlookers doubtless celebrated the achievement in the nearest Tetley pub, for in Leeds the name of Tetley is not only synonymous with the enjoyment of beer, it ranks almost as a religion.

For centuries Leeds has been the centre of a great brewing trade, and at one time breweries were so numerous that they had the benefit of special legislation. In 1393, an ordinance for the price of victuals and drink was proclaimed in a full court at York:

'By the advice and consent of our lord the King's Justices in manner following: Good wheaten bread, four loaves for one penny; strong beer, per gallon, one penny; and claret wine, eight pence per gallon.'

As Alfred Barnard pointed out in his *Noted Breweries of Great Britian and Ireland* published in 1889:

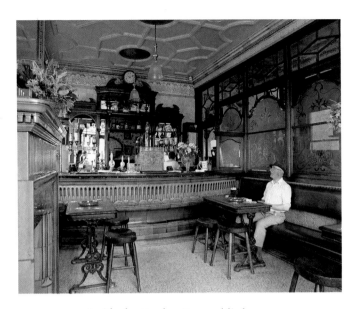

Inside the Garden Gate public house.

The ornate frontage of the Empire Theatre, which is now the Empire Arcade. The theatre closed with a performance of *Babes in the Wood* on the 25th February 1961.

'Those dwellers in, and visitors to the great manufacturing town of Leeds who have crossed the old bridge from Briggate, can scarcely fail to have observed the array of tall chimneys which meets the eye on the left side of the eastern extremity, each one serving as a kind of beacon to the great buildings beneath, and all of which belong to Tetley's Brewery. Indeed, this mammoth establishment is as distinguishable on this side of the river, for its tall chimneys and numerous piles of buildings, as the other side is for its great woollen and other manufactories . . . Tetley's is a vast brewery, whether we regard the extent of the premises comprised in it, the amount of capital invested and by which it is maintained, or the systematic arrangements by which the daily operations are conducted.'

Brewers Challenge Houdini!

MR. HARRY HOUDINI,
Empire Theatre, Leeds.

Dear Sir,—

We herewith **challenge you to allow four of our Employees to fill that tank of yours with beer,** and if you accept our defiance, name your own time. Our men will be at your disposal with the required amount of the beverage.

Awaiting the favour of an early reply.

JOSHUA TETLEY & SON, LTD.,
BREWERS, LEEDS.

CHALLENGE HAS BEEN ACCEPTED

FOR

SECOND PERFORMANCE

TO-NIGHT, THURSDAY, FEB. 9TH

AT

EMPIRE THEATRE.

The above Challenge and Acceptance is unique from the fact that it is positively the first time that such an affair has ever taken place in any part of the world.

Announcing the only challenge that ever defeated Houdini – and nearly killed him in the process.

Now a century later part of the great Allied Breweries group, the brewery has grown bigger under continuous modernisation, and can produce in excess of 7,000,000 pints a week to supply its many outlets – for there is hardly a street in the city without its Tetley pub providing a major source of relaxation and enjoyment.

A jewel in the Tetley estate, claimed to be 'one of the finest examples of a Victorian public house in Yorkshire if not in Britain', is undoubtedly the Garden Gate inn at Hunslet, tucked away in the middle of a modern council estate. It stands on a plot of land bought for £55 18s in April 1826 by local gardener Thomas Walton. The first mention of an inn on the site came in 1833 when his widow, Sarah, was seeking a separation from her second husband Matthew Kearsley, who was described as an innkeeper. Sarah died in 1841 and on the 1st May 1849 the inn was bought by Henry Williamson for £680; it is in this transaction that the inn is first referred to as the Garden Gate. It passed through various hands before being acquired by Tetleys in the 1960s, when demolition was proposed as part of a redevelopment of the whole locality. Regular patrons caused a furore and the pub was saved, listed as a building of special architectural merit.

The entrance hall is worth a moment for the quality of its mosaic floor tiles, but the tap room to the front left is the real gem. The walls and the splendid bow-shaped bar front are tiled in cream, pale green and bronze. And the furniture, as well as some of the customers, look as though they have been settled happily since the turn of the century.

Undoubtedly the most famous theatrical hostelry in the city survives as Barneys in White Swan Vaults in Swan Street, where a coaching inn is said to have stood as far back as 1799. It is better known as the City Varieties, setting for *The Good Old Days*; one of the most popular television programmes ever transmitted

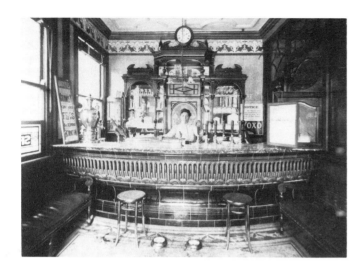

The interior of the Garden Gate pub at Hunslet around the turn of the century. Behind the bar is Mrs Alice Sewell, wife of former licensee Robert Sewell. They had nine daughters and two sons.

by BBC Television, it was produced by Barney Colehan – hence the name.

When Charles Thornton became licensee of the White Swan in 1857, music hall in Leeds was restricted to the Casino in King Charles Croft, noted for both the low order of its entertainment and its patronage. Next door was William Thorne's New Theatre, devoted to legitimate drama. When entrepreneurial Joseph Hobson purchased the Casino in the 1860s and raised its standards by securing a dramatic licence, the Casino became the Royal Ampitheatre. This sealed the fate of the New Theatre, which Hobson bought and transformed into the Princess's Concert Hall. When it reopened in 1864 with noted vocalists – who proved to be less of a crowd-puller than 'Professor Stephens' Performing Gorillas' – it became the Princess's Palace Music Hall.

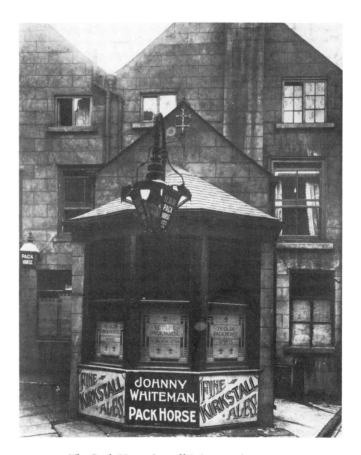

The Pack Horse inn off Briggate, about 1908.

Noting the success of the gorillas, Charles Thornton decided to rebuild the White Swan as a music hall, but with the added insurance of the public house in the vaults. The White Swan Varieties opened in June 1865, subsequently being billed as 'Thornton's New Music Hall and Fashionable Lounge'. Added to this was the information that the entrance was from Briggate and that the establishment was patronised by 'the elite of Leeds'.

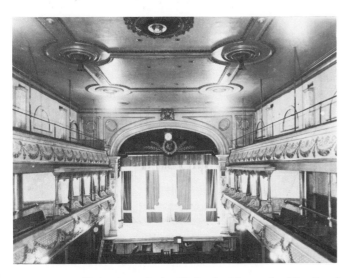

Known to millions through the BBC television series *The Good Old Days* is the City Varieties Music Hall, whose tiny stage has been graced by most famous entertainers.

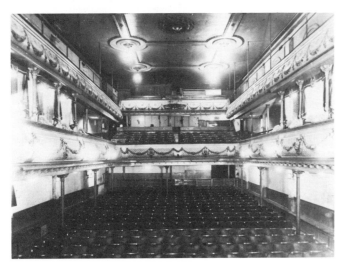

The ornate interior of the City Varieties has been preserved for posterity.

The Varieties and the Princess's Palace both prospered, but in the 1870s several rivals opened up in competition, and Thornton retired from the licensing trade to devote himself to the erection of his shopping arcade.

In 1876 the Varieties was offered for auction, but withdrawn when only £10,000 was bid; it was subsequently sold and reopened in 1877 as Stansfield's Varieties. One programme of 1878 began with the overture at 7pm and ended with *God Save the Queen* at 10.30pm. It contained character and serio-comic songs, a horizontal-bar performance and hat-throwing entertainment, a Lancashire sketch (*The Factory Girl*), a Yorkshire dialect reading and many other 'exciting and mirth-provoking' items. So the price of a glass of ale included taking part in a rollicking, boisterous floor show. For the next twenty years the Varieties had a chequered history, but it succumbed in 1898 to the commercial pressure of the Moss Empires' syndicate, who opened the huge Empire in Briggate. Salvation came in the form of an enterprising publican called Fred Wood, who ran the Scarbrough Hotel (always known as the 'Taps') in Bishopgate Street, which had a singing room where the great Dan Leno is said to have once appeared. Wood bought the Varieties when rumour had it that the place was to become a warehouse, and he reopened it on the 1st November 1898 with a strong bill topped by comedian Alec Hurley, who later married Marie Lloyd. The printed programme advised that henceforth 'a strong effort would be made by the management to cater for the comfort and amusement of patrons'. These 'strong efforts' were, in fact, attempts to discover new talent without undue costs by trying out performers at the 'Taps' singing room first. As a result, several 'unknowns' went on to appear at the Varieties, and at least one went on to top the bill at Blackpool Hippodrome. In addition, such stars as Lily Langtry, George Formby, Harry Lauder, Vesta Tilly and Harry

Houdini trod the boards of the Varieties.

In 1902 electric lighting was installed as part of a total renovation, and the enterprising Fred Wood took over the Queen's Theatre at Holbeck, home of lurid melodrama. He turned that into a music hall before renaming it the Queens Palace of Varieties, upon which the Briggate house became the City Palace of Varieties, soon abbreviated to the City Varieties, as it is known today. In 1913 Fred Wood died, and the Scarbrough Hotel and the two music halls were sold by auction. The Queens became a cinema a decade or so later, but the City Varieties remained loyal to live entertainment. Its survival was secured in 1941 when it was bought by Harry Josephs, who died in 1962, but his sons Michael and Stanley carried on the tradition. Among famous modern stars given their first chance there are such favourites as Derek Roy, Max Bygraves and Frankie Vaughan, whilst the 900 seat hall entered in 1969 into the second century of its life with typical Victorian serenity.

There is, however, an element of mystery about the theatre which even renovation has failed to dispel. For instance, the coat of arms over the proscenium arch is reputed to have been conferred on the Varieties by King Edward VII who, when Prince of Wales, was fond of visiting music halls. He is said to have escaped from dull parties at Harewood House to enjoy an hour or two in box D to the right of the stage. It was discreetly curtained off, and the attendants were sworn to secrecy.

Two ghosts haunt the building, both dressed in Victorian-style clothing. One is a man who sits at the piano and the other is a woman singer. Who they are is not known. Perhaps two 'discoveries' who did not make it to stardom?

International stardom awaited a boy who was part of an act called the Eight Lancashire Lads which appeared at the City Varieties in 1896. His clog-dancing routine took him around the theatres for eighteen years, until he got his break in films. There he played the Little Tramp – his name, Charlie Chaplin.

The new moving pictures brought to Leeds as early as 1912 'Kinemacolour, the only process in existence to show animated pictures in the actual tones and hues of nature'. The Majestic Cinema – which replaced the Phoenix Temperance Hotel – on the corner of City Square was opened in June 1922, and closed as a cinema on the 10th July 1969 to be reborn as a bingo hall. Boom time for the cinemas was in the 1930s when the talkies had become established. Large, purpose-built cinemas began to sprout, like the Ritz in Vicar Lane, seating 1,950. By 1933 the *Yorkshire Evening Post* revealed that there was one cinema seat for every nine of the population, and this in sixty-eight cinemas. But in Leeds, as elsewhere, changing fortunes and fashions, together with the domestic convenience of television, caused the demise of the silver screen. Although some cinemas remain, others gave way to supermarkets and light industrial premises. Ironically, the popular Hyde Park Picture House had opened on the 7th November 1914 in a converted social club and hotel.

One of the pleasure resorts of early Victorian Leeds was the Zoological and Botanical Gardens at Headingley, which were eventually taken over by a well-known Leeds amusement caterer called Tommy Clapham. Construction of Cardigan Road in 1858 saw the closure of the gardens, and the surrounding land was sold off for building plots, leaving only the old bear pit. Clapham removed his activities to Woodhouse Moor, where he constructed and opened the Royal Park and Horticultural Gardens, popularly known as Tommy Clapham's Park. Advertisements of the time claimed it possessed 'the largest dancing platform in the world', but it closed about 1890 and the land was sold for building to feed the needs of the expanding town.

There could be no greater contrast between the

The mansion, Roundhay.

urban concrete jungle and Blake's 'green and pleasant land' than the Elysian fields of Roundhay Park.

Round-haigh – *haigh* is Saxon for hedge – was the round enclosure set apart for hunting purposes, and it appears that the Roundhay of yesteryear was a royal chase for the Anglo-Danish and Norman kings and lords. But the park was separate from the manor, which was bought by Stephen Tempest in 1629 for £850. Unfortunately his loyalty to the king in the Civil War led to forfeiture of his estates to Parliament. The manor was sold to William Lowther of Ingleton, from whom it descended to his nephew Sir John Savile of Methley. In 1811 it passed to Thomas Nicholson.

In September 1271, King John came to hunt deer in

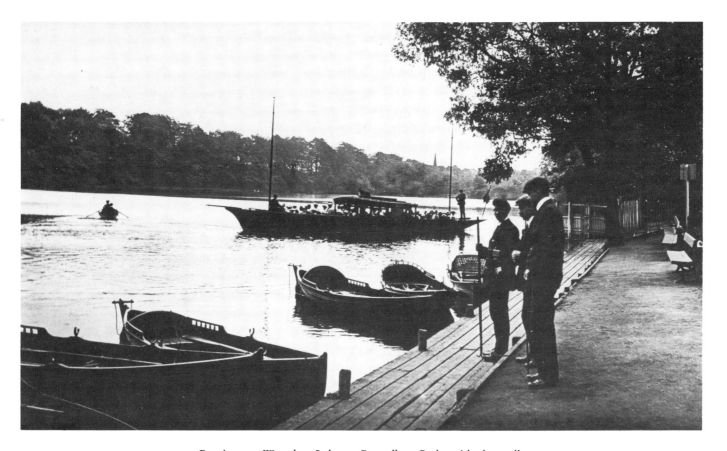

Boating on Waterloo Lake at Roundhay Park, with the well-known pleasure cruiser *Mary Gordon* leaving with a party on board, sometime early this century.

the parkland, and it would appear that there was a game warren enclosed by a circular hedge or fence. Support for this contention comes from an expense account of 1321–2 which shows:

'In food and stipend from one "paliciator" resetting and remaking the palings about la Roundhaye 26 weeks and 3 days, 15s 5d.'

Early in the sixteenth century the game park was let to the Archbishop of York, but in 1512 it was granted to Thomas, Lord D'Arcy. He was executed in 1537 for his part in the Pilgrimage of Grace, and his estates forfeited to the Crown. The park was then reported to cover 200 acres, and was let to Lawrence Baynes for forty years at a rental of £20 a year. From him it passed through various hands until being sold on the 14th August 1803 to Thomas Nicholson.

A corner inside Roundhay Park tropical house.

Canal Gardens, Roundhay Park.

In 1818, Nicholson had built for him by Clark of York a beautiful house – now the Mansion Hotel – on the crest of an eastward-facing slope. Through the surrounding estate ran Wike Beck, so in the acute depression resulting from the Napoleonic Wars he arranged for a quarry on his land to be transformed into a lake – Waterloo Lake. There is enough water to accommodate several hundred fishermen, whilst at the same time large rowing boats navigate its deepest parts, which are said to be of incredible depth. Complementing it is the smaller Upper Lake.

Tradition has it that Nicholson liked the sea so much that he wanted to be reminded of it by having a third lake; this was planned for the site of the present arena, but he died on the 14th January 1821 before it could be accomplished. He is also said to have claimed that the owner of Roundhay was entitled to a belt of neighbouring land a deer's leap in breadth beyond the boundary fence of the ancient park, a privilege known as the 'Roundhay Gold Lace'. After his death the estate passed to his nephew, who died in September 1868, and four years later the mansion and park were bought by Leeds Corporation.

A major influence in securing the property was Sir John Barran, who also brought the multiple clothing industry to Leeds. He stood up in the council chambers in 1868 and said of the Nicholson property, then being offered for public auction:

'Here we have an estate which would make an ideal playground for the people of this town. Future generations will remember us with gratitude as they

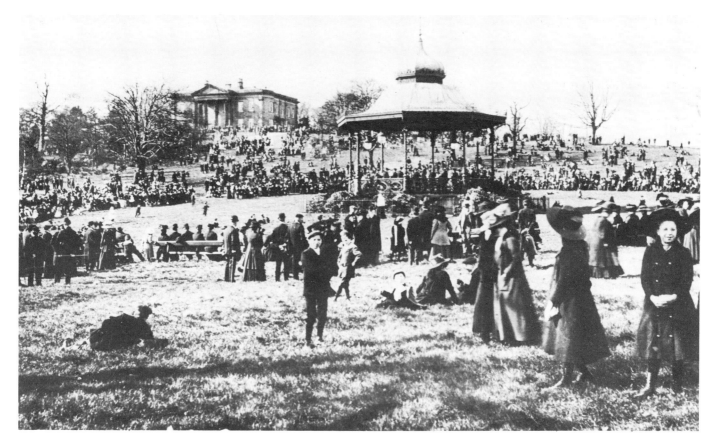

A band performance in Roundhay Park about the turn of the
century.

stroll along the pleasant walks and enjoy the ease and shade of the trees . . .'

How right he was, but at that time there was considerable opposition to the proposal, for the law did not permit the council to spend more than £40,000. To overcome this problem, Sir John and his friends loaned cash to buy the park, but he was attacked for 'criminal waste'. In 1882 the council was still enduring censure for being party to a deal which had cost £139,000. Critics called it a white elephant, but in 1894, when the great electric tramway had been laid down enabling ordinary folk to reach the park for the first time, controversy died and Sir John was looked upon in a new light. Unmoved by the criticism, on the 3rd April 1882 he presented a memorial fountain which commemorates his foresight.

There have been some remarkable gatherings in the park over the years, but probably one of the largest was the crowd of 80,000 who assembled to see a Rolling Stones concert here in 1982 – although the military tattoo which was the grand finale of the nine day tercentenary celebrations in 1926 is said to have attracted a crowd of 100,000.

More partisan were the crowds who turned out to watch the sporting diversions held at Chapeltown during the emergent days of the town. Even the prurient Leeds chronicler Ralph Thoresby (1658–1725) seems to have been excited at the presence of famous runner Edward Preston. Thoresby says:

'Gentlemen have come, to see him run, from Newcastle, Chester and London itself, by the same token that one of them, being fatigued with his journey, lay down to take a nap, and awakened not till the Sport was over. He frequently ran twice round that (Chapel-Town) Moor (a four Miles Course) in about fourteen minutes [forty minutes seems more likely]. It has been modestly computed, that Three Thousand Pounds has been won upon his Head (or by his Heels rather) at one Race, so that he seems to have merited the Title of Harefoot as well as King Harold himself, who was so stiled for his swiftness.'

Swift footwork was a prime necessity for the participants in another once extremely popular Leeds 'sport' – cockfighting. There were numerous cockpits in the town, one of which was at the Rose and Crown coaching inn, on whose site now stands Queens Arcade. In its early days the 'cockings' at the Rose and Crown were of frequent occurence, and the following advertisement taken from the *Leeds Intelligencer* of the 24th May 1757 is but a fair sample of many others of a similar kind:

'To be fought at the Rose and Crown, at the Back of the Shambles, a Main of Cocks, betwixt the Gentlemen of Leeds and Gentlemen of the West Riding, for 4 guineas the battle, and 40 the main or odd battle. To show 31 for the main and 12 for the bye-battles. To weigh on Sat., 28th May. To fight, 30th, 31st, and 1st June. Feeders – Abraham Farrar for Leeds and Wm Beeston for the West Riding.'

From the size of the prize money this would appear to have been akin to a football league fixture, compared to a cup final announcement like:

'At Mr John Newsham's at the Talbot in Leeds, will be fought a Cock Match, betwixt the Gentlemen of Lancashire and the Gentlemen of Leeds, for ten guineas a battle, and one hundred guineas the odd battle.'

Explaining that you are a 'Gentleman of Leeds' to the natives in some small town or village on the Continent may be rewarded with a blank stare. Try mentioning the city soccer club and their faces will light up: 'Ah! Leeds United!', they say. It was not always so, but the club's many successes at national and international level have inevitably rubbed off on the city and, as a by-product, have led to the many expensive improvements that have made Elland Road one of the best football stadiums in the country.

Similarly well-equipped to cope with big crowds is the Leeds Rugby League Club ground at Headingley, whilst New Hunslet and Bramley rugby league clubs ably maintain their reputation for first-class open rugby amongst fans in South and West Leeds. Hardly less famous is rugby union, with clubs like Headingley and Roundhay commanding enthusiastic support.

Leeds Rugby League Club, of course, shares with the Yorkshire County Cricket Club the splendid Headingley ground, where many historic Test matches have been decided, as well as the traditional Roses match between Lancashire and Yorkshire when the prejudiced exhortations of the supporters are themselves an entertaining diversion.

Certainly they are more vociferous than the indolent crowd of spectators who gather in Victoria Square to watch enthusiasts tackle the giant

Playing outdoor chess in Victoria Square.

chessboard laid out on the pavement.

The variety of sports and pastimes that appeal to the citizenry may have changed over the years, but at least the corporation no longer feel obliged to complain, as they did in 1662, that:

'... many masters of familyes and parents of children doe give libertye to their servants and others, to profane the Sabbath, by their open playing in the streets, sitting in publique places in great companyes, to the great dishonour of God in poynte of divine worshippe, in scandall to Christian profession, and to the bad example of the younger sort in poynte of education.'

All Kinds Of Everything

'There is a great deal of accessory sculpture – gargoyles, lions, etc – which is more restless than interesting. The gargoyle is a form of parasite which rather infects Leeds modern architecture, and seems to attack all sorts of buildings, Gothic and Renaissance alike.'

So commented *The Builder* on the 19th December 1896. Consequently, on the remaining Victorian and Edwardian buildings which have not yet fallen victim to the developers and the demolition gangs, there lurks a kind of horrific zoo; a fantasy of basilisks, hippogriffs, krakens, gryphons, cherubs, nymphs, and – as far as I know – saggitaries and hamadryads for good measure.

The increasing importance of financial institutions in the Victorian economy is manifested in their numerous prestigious buildings. Between 1859 and 1869, nine new banks opened in Leeds, bringing the total number to twelve. Early banks had been housed in accommodation originally built for other purposes, but from 1860 onwards, purpose-built premises appeared in styles which signified respectability and authority.

The provision of a bestiary seems to have been deemed the crowning glory of a new bank, office or even a commercial building. So the Yorkshire Penny Bank in Infirmary Street, built by Perkins and Bulmer and opened in 1859, is liberally hung about with crowned heads of lions, bulls with rings in their noses, lap dogs, horned goats, eagles and dragons. Sprouting high overhead from the main tower of the building – and peering down with a glassy stare like a bank manager refusing a request for an overdraft – are four ferocious looking long-necked dragons.

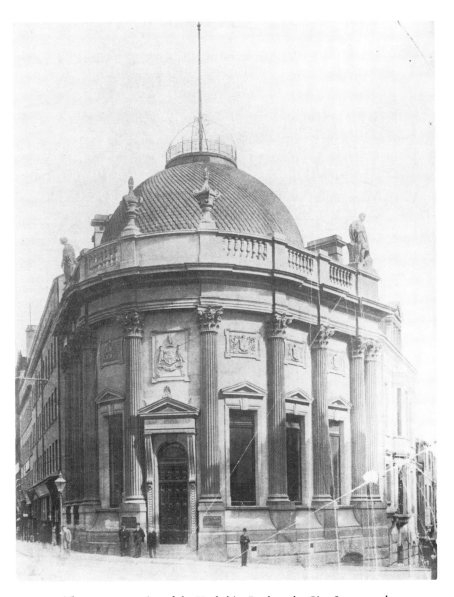

The ornate exterior of the Yorkshire Bank at the City Square end
of Boar Lane.

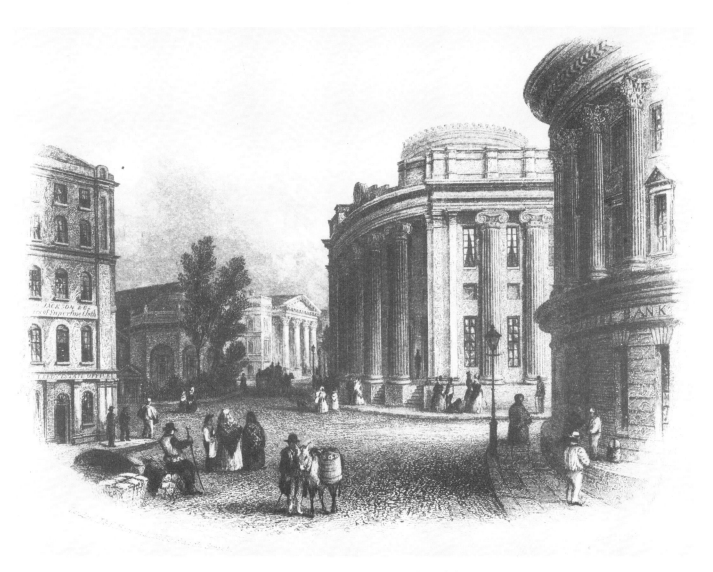

The court house, commercial buildings and Yorkshire District
Bank from an engraving of 1842 – now City Square.

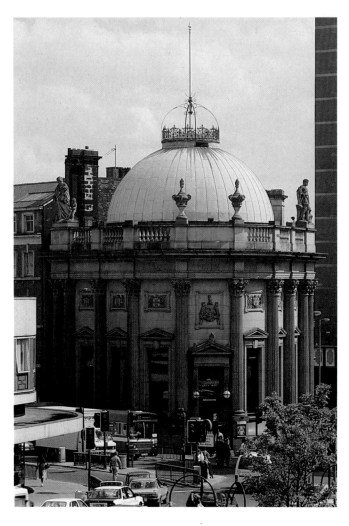

Statuary surmounts the former Yorkshire Bank building at the City Square end of Boar Lane.

Even more striking are the figures in Boar Lane on the building opened in 1899 as the headquarters of the former Yorkshire Banking Company. Now it serves as a public house and restaurant, but it is still dominated by the massive figures representing occupations of the district. A giant gowned lady holds a sheaf of corn and a sickle, whilst a sheep crouches at her feet; all of which signifies the agricultural nature of the bank's interests. Lest anyone be in doubt, there is a youth alongside with a plough. Presumably the whole ensemble characterises Mother Earth. Around the top storey are coats of arms representing Pontefract, Hull, York, Bradford, Dewsbury and Wakefield.

Some inspired examples of the stonemason's art surmount the Trustee Savings Bank at the junction of Kirkgate and Vicar Lane. Together with a kind of horse-beast sporting a lion's tail, a lion, two lambs and two crests, is a classic incentive to bank here in the shape of a statue of Midas, the king of Phrygia whose touch turned all to gold and on whom Apollo bestowed the ears of an ass.

Anonymity surrounds the six carved heads on the entrance to Thornton's Arcade, and one suggestion is that they have a theatrical connection and are effigies of characters in dramas. Whoever they are, we can be sure that Queen Victoria is not amused. Complete with orb, shield and a crown, she dominates the skyline above an electrical engineering showroom in New Briggate. The sculpture bears little resemblance to traditional pictures of the queen. Legend has it that the figure is the queen when she was aged between eighteen and twenty-three, at which time the structure was erected and called Queen Victoria Buildings.

Looking down on the stone lions crouching outside the town hall, from a perch between two flanking griffins high above the Pearl Assurance Building, is a life-size statue of Patrick James Foley. Disfigured by the ravages of wind and rain, the effigy is a perpetual reminder of the president and founder of the company

for which he laid the foundation stone on the 14th July 1910. He was also Member of Parliament for West Galway. Born in 1836 of parents who had moved to Leeds owing to desperate labour problems in Connaught, he worked in Armley as an engineer and later became a clerk. At the age of twenty-seven he began in London a business association with others which developed into Pearl. He died on the 28th June 1914.

Death came unexpectedly on the 31st October 1984 to a brave policeman who is remembered by a four feet high red-brown granite memorial raised by public subscription in Kirkgate. It marks the spot where police sergeant John Speed was gunned down and killed while going to aid his badly-wounded colleague, police constable John Thorpe, who had been shot when he went to investigate a report that a man had been seen tampering with a car parked opposite the parish church.

Barely getting a second glance these days is the war memorial which caused a storm of controversy in the 1920s. For Eric Gill's once infamous bas-relief to the fallen of the First World War tends now to be regarded as just part of the furniture in the foyer of the Rupert Beckett building at the university.

The Driving Out of the Money Changers was commissioned in 1922 by the then university vice-chancellor, Sir Michael Sadler. Gill, the master stone-carver, wood-engraver and author, set to work and by the following year the soft Portland stone memorial was finished and unveiled by the Bishop of Ripon. The arguments were just beginning though. The large wall sculpture depicted Christ in priest's clothing, chastising the usurers – and it was the way the usurers were dressed that angered Leeds folk. Gill had carved them in what was then modern-day dress to look like Leeds manufacturers, their wives and servants. A woman carried a vanity bag, for instance, and a man in the work carried a pawnbroker's sign, whilst overall

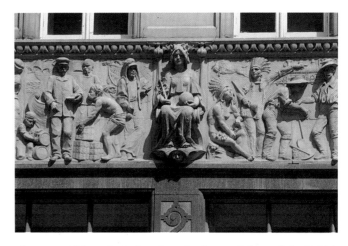

The carved frieze depicting the splendours of days of the British Empire which survives on property in Bond Street.

there was an unhappy resemblance to the average sort of citizen found on city councils.

For nearly forty years, Gill's work was on the western buttress of the Great Hall, a few yards from University Road. (An amusing tale relates that a later vice-chancellor, Sir James Baillie, disliked the work so much he tried to have ivy grown over it.) By the early 1960s, the smokey atmosphere of Leeds was having its effect on the soft stonework, and it was decided to clean it up and place it indoors.

Carvings and inscriptions on gravestones provide some fascinating insights into the Leeds of yesteryear, making Beckett Street Cemetery a magnet for the social historian. It opened its gates for the first time on the 14th August 1845 to receive the tiny body of Thomas Watson Hirst aged nine months of Joys Fold, York Road, and over the next 150 years 180,000 people were interred in some 28,000 graves.

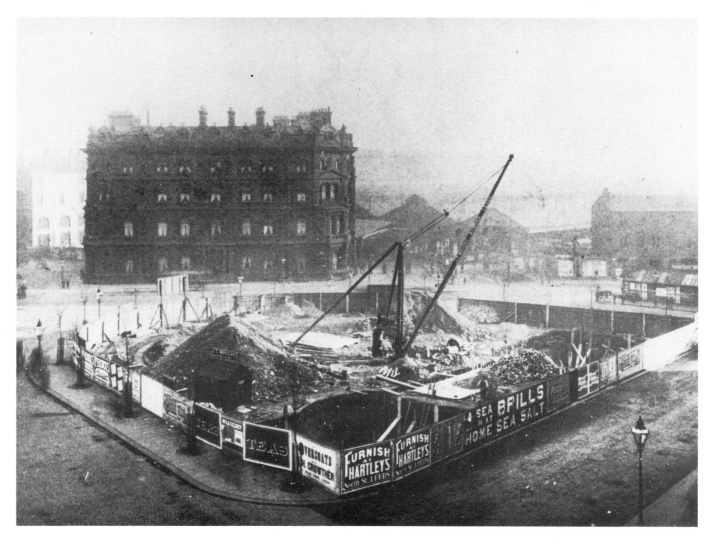

The making of City Square.

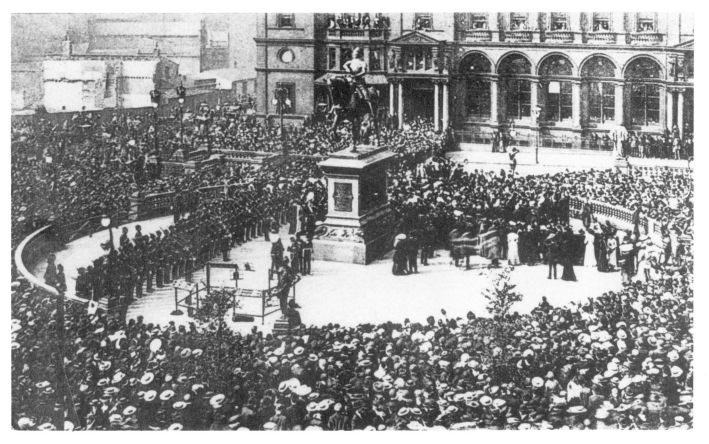

More than 100,000 people gathered to see the presentation of the
Black Prince statue in City Square, a gift from Colonel Harding.

Here is to be found the soldier's epitaph, for instance, which proclaims proudly that he was one of the 'gallant 600' who rode into the 'valley of death' at Balaclava. A tombstone draws attention to 'John Groundswell who died when a prisoner of war at Andersonville, Georgia during the American Civil War, October 1866'.

Another commemorates the sad tale of Fred Smith. Filled with youthful excitement on a June day in 1932, twelve year old Fred mounted his bike and rode off to Middleton Park to see Sir Alan Cobham's Flying Circus. During the performance, a great Handley-Page airliner was sucked downwards by a current of air towards the knoll where the young lad was watching, and poor Fred was killed outright. The experienced pilot was completely exonerated at the subsequent inquest – but the bitterness of Fred's parents is there for all to see on his memorial.

A reminder that the skyline was once punctuated by numerous chimneys is the miniature factory chimney which serves as a tombstone for 'Thomas Kidney, The oldest steeplejack in England who died Nov 17th 1914 aged 82 years'.

One of the most puzzling is the very tall, thick 'broken column' with a garland of stone roses that marks the grave of William Lee, who died in 1853 at Imbault, France. The inscription tells us that he was the discoverer of that useful remedy(?) brandy and salt. We are left to ponder what condition required the use of his remedy – and whether it did any good!

Brandy, beer and other beverages are served across a Biblical bar at the Bridge Inn, Kirkstall, where patrons are confronted by Noah, Samson and the rest, enshrined in old oak carvings believed to be more than 300 years old. Their origin was a mystery for many years until 1982, when a property surveyor spotted a dining-out feature in a local newspaper. Apparently the carvings were dismantled from an old oak court cupboard which originally came from Wennington

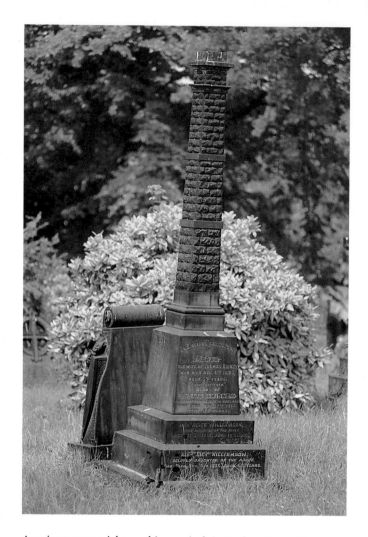

A unique memorial to a chimney jack in Beckett Street Cemetery.

Hall, Lancaster. The panels show the Last Supper, the birth and baptism of Christ, and Noah and Samson. But the mystery of who carved them is still unsolved, to the chagrin of many customers who place their last orders before the Last Supper.

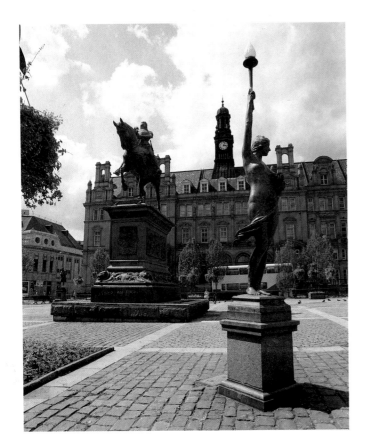

The Black Prince and one of the female statues which aroused considerable interest in City Square.

The statue of Circe in Park Square.

Here, too, patrons over the years have debated the changing scene in City Square – more a triangle – which was bought by the corporation in 1889 for £66,000, and is dominated by a statue of the Black Prince donated by Colonel Thomas William Harding. The bronze equestrian statue of Edward the Black Prince in full armour stands on a bronze and polished granite pedestal, the whole being about thirty feet high. The pedestal is ornamented at the four corners with leopards' heads and a scroll on which appear the names of Sir John Chandos, Sir Walter Nanny, William of Wykeham and Du Guesclin, all of whom were associated with the period of Edward III. Bronze panels on two sides of the pedestal illustrate battles, with Crecy on one side and the sea fight at Sluys on the other. A plaque is inscribed:

'Edward, Prince of Wales, surnamed THE BLACK PRINCE. The Hero of Crecy and Poitiers. The Flower of England's Chivalry. The Upholder of The Rights of the People in the Good Parliament. 1330–1376.'

When formally handed over to the city on the 16th September 1903, this monument stood on a raised circular platform about 100 feet in diameter, surrounded by a balustrade on which were eight statues of allegorical figures representing 'Morn' and 'Even'. Two triangular spaces terminated in an outer balustrade on the northern side of the square, and on this were statues of Joseph Priestley, Dean Hook, John

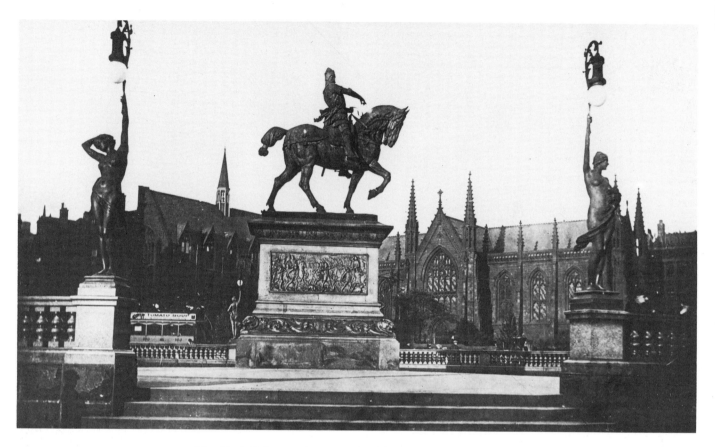

The Black Prince and statuary in City Square, with Mill Hill
Chapel behind.

Harrison and James Watt. Harding's choice of subject caused much speculation, and he said that, as he did not know of any historic figure specially connected with Leeds which would be suitable, he chose a national figure, and considered Henry V and Simon de Montfort before settling on the Black Prince. However, the following day the *Yorkshire Post* commented approvingly:

'The City Square statuary may be differentiated from all other statuary in that it represents a logical, coherent, and well considered scheme. All the statues (excepting Drury's 'Morn' not completed in time) have been seen at various Academy Exhibitions during 1899 to 1901. They may all be characterised as excellent examples of the work of the younger generation of contemporary sculptures, miles above the ordinary run of memorial sculpture in vitality and force.'

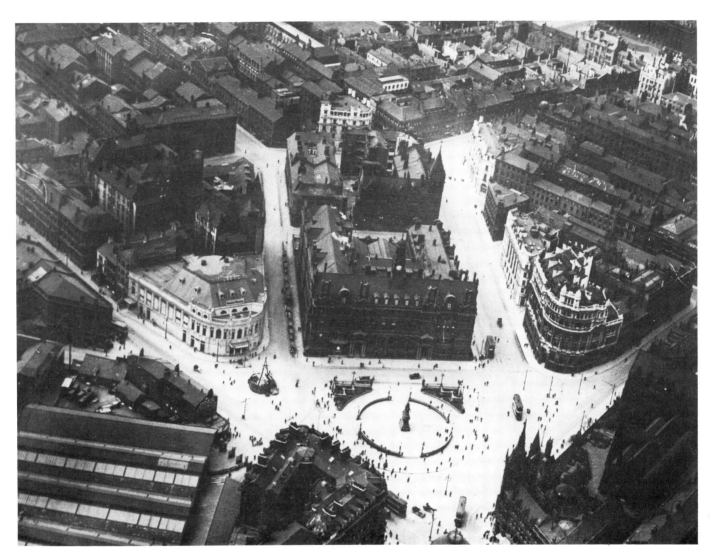

An aerial view of City Square showing the dominant General Post
Office building in the centre and the Majestic Cinema on the left.

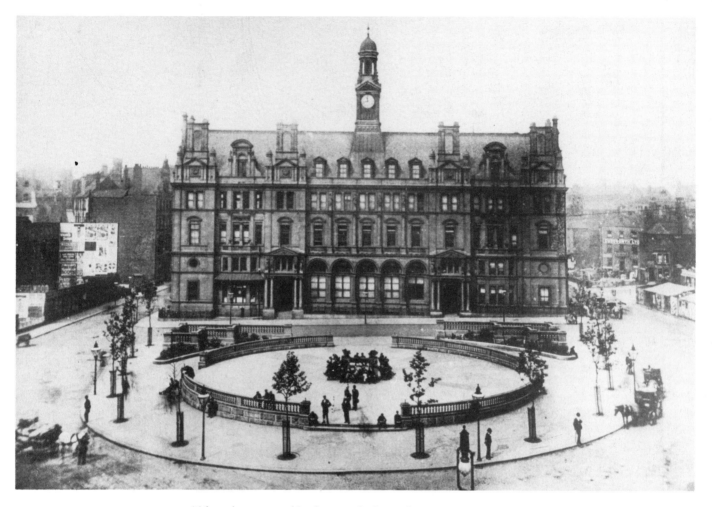

Taken about 1900, this photograph shows the 'new' General Post office overlooking City Square before the statue of the Black Prince was installed.

In 1961 the square was remodelled, during which the figures of 'Morn' and 'Even' were removed and were not immediately replaced on its completion. The four remaining figures now looked down upon a paved area of chequered squares around the Black Prince.

Protests at the possible sale of the statues led to their return; the nymphs were finally restored – facing east and west as appropriate – in July 1962 after a £2,000 offer for them had been turned down. For many years, Colonel Harding paid for a uniformed attendant to

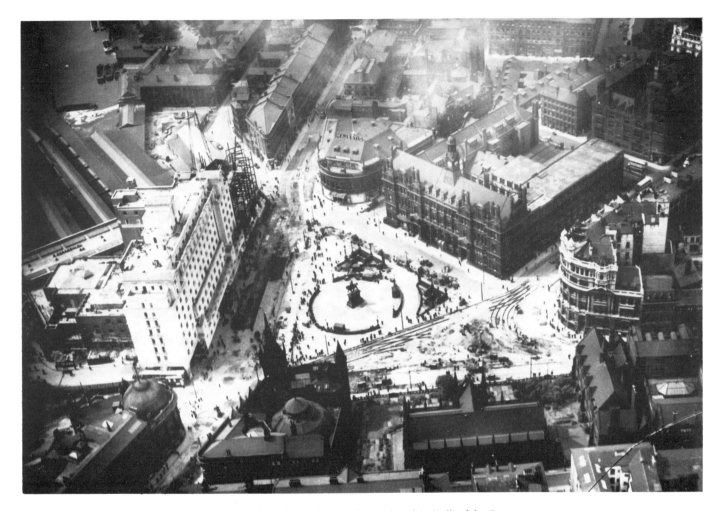

This aerial view of City Square shows the white bulk of the Queens
Hotel and railway station on the left, and tramlines for the many
services that once radiated from here.

look after the square and stop people striking matches
on the ladies' bottoms!

Perhaps the outlook was best summed up by
Hamilton Thompson, a professor of medieval
archaeology some sixty years ago, who was moved

from his usual constraint and academic dignity to write
of City Square:

'If there is some discrepancy between the Black
Prince on his charger and the dishevelled ladies who
hold lamps upon the circumference of the circle, and

The Moot Hall stood at the top of Briggate.

1. The Queen's Room. 2. The Central Court. 3. Vestibule and Staircase. 4. North Room. 5. Arcade in Central Court, with Fountain.

MUNICIPAL ART GALLERY AND MUSEUM. LEEDS.

Five interior views of the art gallery and museum from the
Illustrated London News of the 27th October 1888.

still less community of sentiment between these nymphs and the four worthies who decorously turn their backs on them to contemplate and address their proclamations to the austere facade of the General Post office, the combination of statuary is at any rate original.'

At least this august gathering appears to have won more of a place in the affection of Leeds folk than the white marble statue of Queen Anne, erected at the expense of Alderman Milner in 1713 to decorate the front of the Moot Hall, which stood at the top of Briggate. First erected as a meeting place about 1620, the hall had fallen into decay at the beginning of the eighteenth century, but by the 5th June 1710 there was 'a design to repair and alter the Moot Hall for the conveniency of the reception of the West Riding Justices who have agreed to keep the General Quarter Sessions for the West Riding here'. Presumably in acknowledgement of that restoration was the donation of the statue, which had the Latin inscription in gold on black marble:

'MARK THIS ELEGANT STATUE (SUPERIOR EVEN TO THAT OF ST PAUL'S IN LONDON) PIOUSLY CONSECRATED TO OUR MOST ILLUSTRIOUS QUEEN ANNE (THOUGH FAR SURPASSING EVERY REPRESENTATION) AND ERECTED AT THE SOLE EXPENSE OF WILLIAM MILNER, KNIGHT, A PRUDENT JUSTICE OF THE PEACE, A FAITHFUL SUBJECT, A NOBLE CITIZEN, AND AN OPULENT MERCHANT.'

For almost a century the niveous queen watched over bustling Briggate. When it was widened in 1825 and the Moot Hall demolished, she was found a temporary home in the new court house in Park Row. Three years later she was placed in a niche in front of the new Corn Exchange at the top of Briggate; and, when this was demolished for the construction of New Briggate, she was removed to the town hall, before eventually finding more permanent residence in the art gallery.

Outside the art gallery, braving everything that the wind and rain, pigeons, sparrows and assorted schoolchildren can throw at it, sits Henry Moore's controversial sculpture *Reclining Figure*. It points the way to the £1,000,000 Henry Moore Gallery extension opened by the Queen in November 1982, an addition to the art gallery built at a cost of around £10,000 and jointly opened by the then Lord Mayor, Alderman Scarr, and the eminent painter Sir Hubert von Herkomer in October 1888. Money for the building came from the public subscription fund established to celebrate the golden jubilee of Queen Victoria. In the early days this also payed for the acquisition of paintings – for never has only work and commerce flourished in the amalgam of toiling humanity that is Leeds.

Bibliography

Anning, Stephen T. *The General Infirmary at Leeds.* Livingston, Edinburgh 1963.

Beresford, M W, and Jones, G R. *Leeds and Its Region.* British Association for the Advancement of Science, Leeds 1967.

Bogg, Edmund. *The Old Kingdom of Elmet and The Ainsty of York.* Heywood, London 1902.

Bradley, Tom. *Old Coaching Days in Yorkshire.* Smith Settle, Otley 1988.

Cooper, T P. *With Dickens in Yorkshire.* Ben Johnson, York 1923.

Doerflinger, Frederick. *Slow Boat through Pennine Waters.* Allan Wingate, London 1971.

Duckham, Baron F. *The Yorkshire Ouse.* David & Charles, Newton Abbot 1967.

Fraser, Derek. *History of Modern Leeds.* Manchester University Press, Manchester 1978.

Hartley, Marie, and Ingilby, Joan. *Yorkshire Portraits.* Dent, London 1961.

Hatcher, Jane. *Industrial Architecture of Yorkshire.* Phillimore, Chichester 1985.

Lackey, Clifford. *Quality Pays.* Springwood Books, Ascot 1985.

Linstrum, Derek. *Historic Architecture of Leeds.* Oriel Press, London 1969.

Mayhall, John. *The Annals & History of Leeds.* Joseph Johnson, Leeds 1860.

Mee, Arthur. *Yorkshire West Riding.* Hodder & Stoughton, London 1941.

Norway, Arthur. *Highways and Byways in Yorkshire.* Macmillan, London 1899.

Nuttgens, Patrick. *Leeds: The Back to Front Inside Out Upside Down City.* Stile, Otley 1979.

Ogden, John. *Yorkshire's River Aire.* Terence Dalton, Lavenham 1976.

Parsons, Edward. *History of Leeds.* Simpkin & Marshall, London 1834.

Pepper, Barrie. *Old Inns and Pubs of Leeds.* Smith Settle, Otley 1988.

Pevsner, Nikolaus. *Yorkshire: The West Riding.* Penguin, London 1967.

Price, A C. *Leeds and its Neighbourhood.* Clarendon Press, Oxford 1909.

Robinson, Percy. *Leeds: Old & New.* Richard Jackson, Leeds 1926.

Slack, Margaret. *Portrait of West Yorkshire.* Hale, London 1984.

Taylor, R V. *Biographia Leodiensis.* Simpkin & Marshall, London 1865.

Thompson, Brian. *Portrait of Leeds.* Hale, London 1971.

Walters, Cuming J. *The Spell of Yorkshire.* Methuen, London 1931.

Photographic Acknowledgements

Thanks are due to the following people for permission to reproduce the following illustrations:

Armley Mills Industrial Museum, p11, 35.
Elida Gibbs Ltd, p89.
Illustrated London News Picture Library, p139.
Leeds City Council Planning Department, p14.
Leeds Reference Library, p2, 3, 4, 5, 6, 7, 8, 9, 13, 17, 19, 20, 21, 22, 23, 24, 25, 27, 28, 31, 34, 38, 39, 40, 41, 42, 43, 45, 46, 48, 52, 53, 55, 56, 57, 61(*t*), 62, 63(*tr,b*), 65, 66, 67, 68(*t*), 70(*t*), 71, 72, 75, 76, 77, 82, 83, 84, 85, 87(*t*), 90, 94, 95, 98, 99, 100, 102, 103, 105, 109, 110, 112, 115, 117(*r*), 118, 120, 121, 123, 126, 127, 134, 135, 138.
Science Museum, p79, 80(*r*).
Yorkshire Post Newspapers Ltd, p50, 53(*tl*), 68(*b*), 70(*b*), 87(*b*), 93, 97(*r*), 106, 108, 113, 117(*l*), 130, 131, 136, 137.

Photographs taken specifically for this book by Richard Littlewood, *x*, 1, 15, 18, 26, 33, 35, 51, 54, 58, 59, 61(*b*), 80(*l*), 92, 111(*t*), 114, 115, 122, 125, 128, 129, 132, 133.

From the author's collection, p16, 44, 88, 101, 107, 111(*b*), 116.

INDEX